The New Décor

The Ne

Décor

Contents

Artists

Sponsor's Foreword

HSBC is sponsoring *The New Décor*, an international survey of artists who incorporate elements of interior design in their work. This forms part of Festival Brazil, a major celebration of contemporary Brazilian culture. HSBC is collaborating on the entire Festival Brazil programme across the Southbank Centre throughout the summer of 2010.

Our sponsorship of Festival Brazil is part of HSBC's Cultural Exchange Programme. As the World's Local Bank, present in 88 countries, we know first hand how important it is to explore and understand different cultures. With a presence in Brazil since 1997, HSBC's operations provide an important source of financial services for the diverse needs of our customer base, ranging from individual Premier customers to importers and exporters and some of the country's largest corporations. HSBC is proud to be an important part of Brazil's continued economic development.

Festival Brazil provides an opportunity to experience the culture of this vibrant country here in London. I hope you are inspired by the tremendous range of work on display.

Stephen K Green
Group Chairman, HSBC Holdings plc

www.hsbc.com/culturalexchange

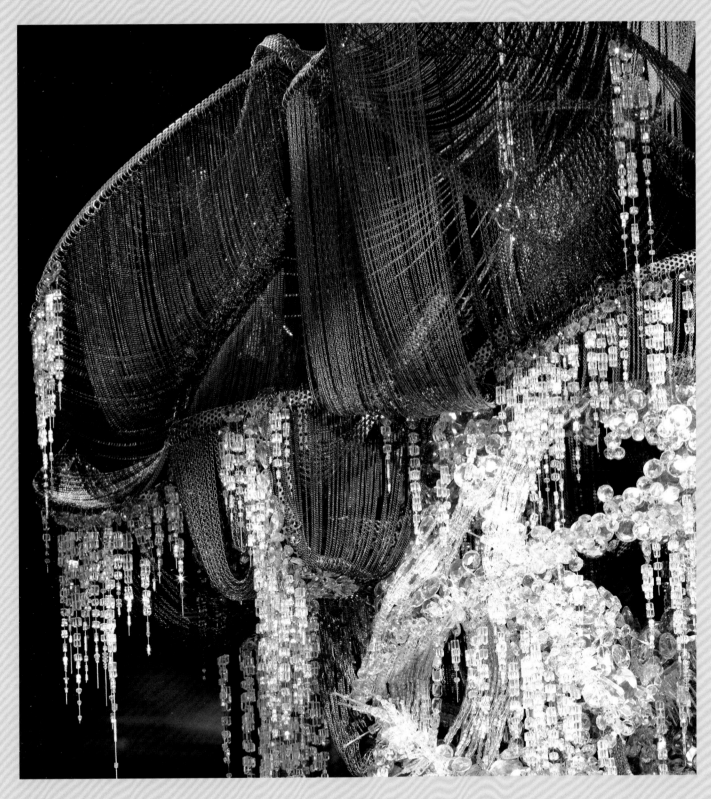

Lee Bul
Sternbau No. 3 (detail)
2007

Acknowledgements

For their generous contributions
to this exhibition, we wish to thank:

Austrian Cultural Forum, London
Marianne Boesky Gallery, New York
Yumiko Chiba Associates, Tokyo

The galleries and studios of the
participating artists helped in many
ways with this exhibition. In particular,
we are grateful for the assistance
of the following people:

Ines Turian, Atelier Franz West; Barbara
Wien, Barbara Wien Wilma Lukatsch,
Berlin; Joaquín García, Galería Helga de
Alvear, Madrid; Karen Tanguy, Galerie
Chantal Crousel, Paris; Raphaël Gatel,
Galerie Emmanuel Perrotin, Paris; Elena
Tavecchia, Galerie Massimo De Carlo,
Milan; Tanja Wagner, Galerie Max
Hetzler, Berlin; Isabella Ritter and
Katharina Zimmer, Galerie Meyer
Kainer, Vienna; Lubi Reboani and
Verusca Piazzesi, Galleria Continua,
San Gimignano / Beijing / Le Moulin;
Karin Seinsoth, Hauser & Wirth; Nicky
Verber and Samara Aster, Herald St.
London; Marika Keilland, Kim Heirston
Art Advisory LLC; Louise Hayward,
Lisson Gallery, London; Carmen
Blánquez, Magee Art Gallery, Madrid;
Annie Rana, Marianne Boesky Gallery,
New York; Chin Chin Yapp and Raphael
Lepine, Phillips de Pury; Pauline Daly,
Sadie Coles HQ, London; Luke Stettner,
Spencer Finch Studio; Andreas Gegner,
Friederike Schuler and Anja Trudel,
Sprüth Magers Berlin London;
Nils Grarup, Studio Elmgreen and
Dragset; Lindsey Hanlon, The Modern
Institute / Toby Webster Ltd, Glasgow;
Erin Manns, Victoria Miro, London;
Susannah Hyman, White Cube,
London; Keiko Mizuno, Yumiko Chiba
Associates, Tokyo.

Preface

The New Décor surveys artworks that revisit and reinvent those most familiar objects in our lives — including chairs, tables, sofas, lamps, beds and doors — in order to explore and question the attitudes with which we furnish our sense of place in the world. Remixing aesthetic codes and categories, this work defamiliarises our habitual relationships with the props of our everyday interiors while it explores an expanded field of sculptural forms, and social and psychological narratives. Ultimately, much of it leads us to reflect on the ways in which our most 'private' spaces are increasingly connected with changes and events in the outside world.

Broadly international in scope, *The New Décor* features 36 artists from 22 different countries. Their work offers us the opportunity to reconsider our encounters with sculpture in the light of how people experience objects in quotidian circumstances and situations in a variety of cultures and societies. The exhibition's global perspective also epitomises the Hayward Gallery's commitment to presenting art from around the world that encourages us to re-imagine conventional ideas about the way we live now.

It has been a pleasure and a privilege to work with the many artists in this exhibition, and our thanks go first and foremost to them. They have enriched us all by making objects that provocatively enlarge our sense of the conceptual and imaginative boundaries of our interior worlds.

We are extremely grateful for the crucial financial support provided by our sponsor HSBC as part of their Cultural Exchange programme. Our thanks also go to the Henry Moore Foundation for their additional support of the exhibition.

It would not have been possible to realise this exhibition without the generosity of the many lenders involved, including individual collectors, galleries, foundations and the participating artists themselves. We extend to them our deep gratitude and appreciation for making these artworks available to the public through their inclusion in this exhibition. I also wish to thank our touring partner, the Garage Center for Contemporary Culture, Moscow. It has been extremely gratifying to collaborate with our colleagues there, and in particular I would like to thank its founder Daria Zhukova, and its director Mollie Dent-Brocklehurst, for their engagement with this project.

It has been an honour to work with the writers Hal Foster and Michelle Kuo, who have contributed essays to this book that brilliantly illuminate the artworks in the exhibition as well as their larger social and art historical contexts. Thanks also to Kirsty Bell, Amy Botfield, Christy Lange, Cliff Lauson, Helen Luckett, Richard Parry and Skye Sherwin for their excellent texts on individual artists. Kate Bell did a superb job project managing this publication, and was ably supported by Amy Botfield and the Hayward Publishing team directed by Mary Richards. It was a delight, as always, to work with A2/SW/HK, who have fashioned the adventurous and intelligent design of this book.

As with any exhibition of this scale, numerous people have provided substantial help and assistance. A list of their names appears opposite. I would like to single out for mention Assistant Curator Richard Parry, who managed the many challenges posed by a large international exhibition with ingenuity and grace under pressure. Exhibitions Assistant Chelsea Fitzgerald provided brilliant support throughout. Head Registrar Imogen Winter adroitly orchestrated transport arrangements for works coming from many lenders and many parts of the world, while Senior Technician Gareth Hughes led the complex installation with consumate skill. In addition, General Manager Sarah O'Reilly did a great job overseeing many the different elements involved in realising this exhibition. Finally, my gratitude goes to Jude Kelly, Artistic Director of Southbank Centre, Alan Bishop, Chief Executive of Southbank Centre, and the Southbank Centre Board of Trustees for their enthusiasm and support for this project.

Ralph Rugoff
Director, Hayward Gallery

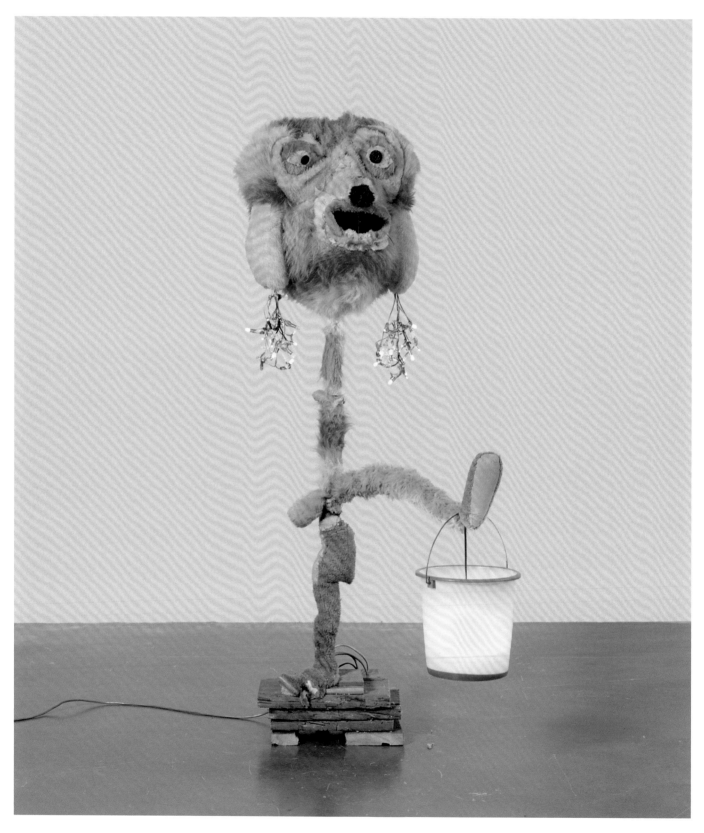

The New Décor

Ralph Rugoff

Enough of the house as an artificial cave: it is more a warping of the sphere of interpersonal relations. Vilém Flusser [1]

Taking the forms and display of everyday furniture as a point of departure, the artworks in *The New Décor* pointedly twist and subvert our conventions of interior space. Rewiring the behavioural cues embedded in décor and unsettling its social and psychological narratives, many of these sculptures convey a breached sense of decorum. The standard etiquette of interior design, and the idealised image of social behaviour that it communicates, is conspicuous by its absence. In its place we encounter objects such as a cannon-powered office chair, a flying table, a lighting fixture that resembles a pile of explosives, and a sculpture that eerily merges a sofa and a memorial. Like items from an interior decorator's anxiety dream, works such as these summon an unstable, restless apparition of décor.

While these sculptures evoke commonplace objects, they do so only to disarm our customary intimacy with them. This is as true of those sculptures that modify parts of existing objects as it is of those that have been specifically fabricated to recall, directly or indirectly, the appearance of furniture. In both cases, the resulting objects appear as perplexed, precarious or troubling — as alienated, in other words — as any subjects who might conceivably 'use' them. Bereft of utopian rhetoric, they offer no vision of art galleries transformed into congenial sites of collective exchange or activity (and in this respect they provide a distinct contrast with design-related art from the past fifteen years that has been associated with 'relational aesthetics').[2] Instead these sculptures imply that a degree of alienation and uncertainty — a sense of not fitting in and not feeling 'at home' — is a crucial benefit of our encounters with art, and integral to its capacity for displacing our readymade ways of relating to the world around us.

Just as the French word *décor* refers to stage sets as well as interior design, much of the art in *The New Décor* seemingly occupies an arena between theatre and everyday life, between the fictional and the empirical. As sculpture that resembles furniture, it inevitably enacts a masquerade of sorts. It assumes a kind of double or in some cases, triple identity, as in the case (to name only one example) of Los Carpinteros' *Cama* [*Bed*] (2007) — a sculptural object that resembles a bed that in turn evokes a motorway overpass. Uncertainly poised between artwork, theatrical prop and décor, such works open up an expanded field of reference and allusion. They transform the self-contained design object into a matrix of associations and ideas, often extrapolating on the ways that décor projects a desired image of the self or arbitrarily imposes one; how it reproduces social relationships or functions almost like a theatrical prop in staging the identity of a person or place. Some works refer to intimate encounters or to political struggles in parts of the world ranging from Palestine to Paris, Beijing to Bogotá. And like *Cama*, many of the sculptures in *The New Décor* combine references to inside and outside spaces, suggesting ways that public and private experience increasingly bleed into each other (sometimes with disastrous consequences).

Gelitin
Untitled
2004

1 Vilém Flusser, *The Shape of Things: A Philosophy of Design*, Anthony Mathews (trans.), Reaktion Books, London, 1999, p. 81.
2 In the mid-1990s, the idea of décor gained attention in art through the work of a number of artists, including Liam Gillick, Jorge Pardo, Tobias Rehberger and Andrea Zittel. To varying degrees, much of this work trafficked in rhetoric around audience engagement, and the use of art as a platform or staging area for collective conversation and activity. In addition, by taking on aspects of design in their work several of these artists were concerned with questioning the art world's conventional terms of aesthetic evaluation and judgement.

Building on the tension generated between its appearance as furniture as well as sculpture, this kind of work articulates an oscillating identity. It engages us as both physical entity and dematerialised sign — as an object in space and as a representation of one. Whereas furniture-like sculptures in the 1960s by Claes Oldenburg and Richard Artschwager primarily alluded to the way that objects are depicted in painting or photography (the skewed forms of the furnishings in Oldenburg's *Bedroom Ensemble* (1963), for example, conjure the perspective and illusory depth of a two-dimensional image, while Artschwager's furniture sculptures, with their *trompe-l'oeil* negative spaces, suggest paintings pushed into three dimensions), the artworks in *The New Décor* often mix up references to a wide range of representational, as well as actual, spaces. Rosemarie Trockel's *Landscapian shroud of my mother* (2008), a low, segmented platform of glazed ceramic and steel in the centre of which lies a black shroud, encompasses references to urban grids and architectural models, Minimalism and memorials. Other works play off associations with the seemingly random spatial orchestrations of abstract painting or the pixels of television programmes (Angela Bulloch), or infuse the utopian dimensions of Modernist architecture with a chaotic baroque decadence (Lee Bul).

At the same time, much of this work implicitly proposes that our encounters with sculptural objects are inextricably linked to our experience of objects in everyday environments. In other words, it positions itself not only in relation to the (abstract) space of the gallery, but also plays on our relationships with social and cultural space. Drawing on our memory of daily physical contact with furniture, it solicits visceral as well as conceptual responses. And while much of this work assumes the scale of ordinary furniture as well as an appearance of functionality (or in some cases, the potential for actual use), it is not chiefly concerned with issues of utility. Instead, it evokes the possibility of use as a way of activating a theatrical framework: taking on the quality of props left on a stage set at intermission, these sculptures engage the viewer as a potential actor in a public drama. Theatricality is a means here not of creating spectacle but of re-staging a relationship that is usually private in order to situate its social dimensions.

Consider Franz West's *Untitled* (2006), a five-and-a-half-metre-high oblong form of painted aluminium with a horizontal lump that protrudes from the vertical 'body' of the sculpture. To sit on this ungainly object a visitor first has to scramble onto the low plinth on which it rests, as if climbing onto a stage for a performance. Sitting on this sculpture is ultimately more of a theatrical action than a practical one, a matter of posing rather than reposing. The seated visitor becomes another element in the display, not unlike the model in an advertisement for domestic goods. In this respect, as Peter Schjeldahl has pointed out, West's wayward décor offers 'a vision of society at once domestic and public, in which everyone is both a spectator and a spectacle'.[3] At the same time, it conflates the theatrical and the social with intimations of visceral experience: while West's sculpture takes it scale from public monuments, its appearance — which suggests an enormous pink phallus or a Pepto-Bismol-coated turd — desublimates the language of biomorphic abstraction to send our thoughts racing back to personal bodily activities.

*

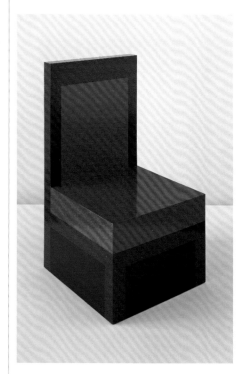

Richard Artschwager
Chair
1963

3 Peter Schjeldahl, 'Just For Fun', *The New Yorker*, 3 November 2008.

Pieces of furniture, like individuals, are contingent; they may fall apart, fold into themselves, or collapse gracefully. Or they might fall on one another. There is a beauty to the failed modern design object and the modern subject. Tom Burr [4]

In taking up décor as a visual reference, sculpture inevitably engages with the connection between furniture and the human body. Furniture, after all, is designed to hold and support us, to accommodate our physical activity, and this intimacy of use is reflected in the anatomical terms used to describe its various parts. We speak of the 'head' of a bed, the 'legs' of a table and the 'back' of a chair. (And this is not merely metaphorical speech: there is no other term to describe the 'arm' of an armchair, for instance.) As if drawing on this linguistic relationship, Rosemarie Trockel's *Table 7* (2008) features a pair of legs that resemble stout, crudely formed human limbs. Their rough appearance disrupts the ceramic table's clean Modernist lines, insinuating a rude return of a repressed body whose physical imperfections look terminally out of place amidst the formal niceties of 'good design'. An unexpected surfacing of bodily content also animates Sarah Lucas' *Fuck Destiny* (2000), which stages an abject sex show enacted by decrepit furnishings, as well as Gelitin's jerry-rigged lamp and sofa (*Untitled*, 2004 and 2009), both of which exude a degraded anthropomorphism by incorporating well-worn stuffed animals into their construction. To some extent, works such as these recall the uncanny furniture-sculptures of Surrealists like Salvador Dalí and Meret Oppenheim, which endowed domestic items such as tables and divans with anatomical attributes. Yet considered against the contemporary background of a burgeoning, consumption-driven design culture, the populist roots of which span IKEA and Martha Stewart to a never-ending plethora of 'home and garden' television programmes, these works seem to re-stage our libidinal over-investment in interior artefacts in terms of a displaced and orphaned physicality.

Claes Oldenburg
Bedroom Ensemble
1963

While not so explicit in their bodily references, many other works in *The New Décor* evince an aura of human frailty, often conveyed by an appearance of precarious and ad hoc facture. As Mona Hatoum has remarked, 'We expect furniture to be about giving support and comfort to the body. If these objects become either unstable or threatening, they become a reference to our fragility'.[5] As if illustrating this point, Roman Signer's *Schwebender Tisch* [*Floating Table*] (2005) takes an object associated with solidity and sets it aloft with jets of air that cause an ordinary wooden table to hover above the floor, jittering with an unsettled, and unsettling, energy. Thea Djordjazde's *Deaf and dumb universe*

4 Quoted in Joshua Decter, 'Tom Burr Talks About *Addict-Love*', *Artforum*, February 2008.
5 Quoted in 'Interview with Michael Archer', in *Mona Hatoum*, Phaidon Press, London, 1997, p. 27.

(2008) and *Zurück zum Maßstab* [*Return to Scale*] (2009) suggest impossibly delicate furnishings made to accommodate the frailest of bodies. While Diango Hernández's sculptures, which often incorporate divided pieces of second-hand furniture, indirectly recall the chopped-up interiors of collectivised homes in Cuba, as well as the social ruptures created in the aftermath of the 1959 revolution.

Bordering on the abject, a number of these sculptures rely on an impoverished or distinctly humble style of construction. Jimmie Durham's *Imbissstammtisch* (1998), a jauntily improvised snack table assembled from junkyard scavengings, suggests the décor for a transient existence in which the security and safety of a fixed address has no place. Heiri Häfliger's *The early bird catches the worm* (2007) rests on wheels like a trailer-home chandelier, a portable piece of deflated grandiloquence, while Pascale Marthine Tayou's *Crazy-Nomad-02/Globe-trotters* (2007), which also sport wheeled bases, conjure nomadic accumulations of disposable identities. Like a totem of an adolescent's failed yearning for identity, Jim Lambie's *Bed Head* (2002), a grubby mattress clad in a makeshift glam-rock jacket of colourful buttons, oozes an aura of unredeemed transformation. Provisional and contingent in appearance, works such as these convey a sense of both physical and social vulnerability.

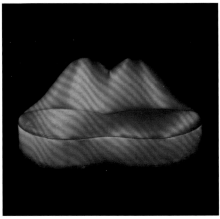

Diango Hernández
*Leg me, chair me,
love me*
2010

Salvador Dalí
Mae West sofa (lips)
1936

In contrast to a cultural landscape dominated by products designed for novelty, maximum entertainment and instant recognition, these artworks summon visions of a décor poised on the brink of illegibility. In articulating an aesthetic near décor's ground zero, they challenge us with a borderline character in which the relationship between part and whole is often ambiguously unresolved. The various constituent elements of these sculptures seem to assert their presence simultaneously, often in tension with the object's apparent aggregate identity. On one level, at least, this kind of precarious *bricolage* bears comparison with a famous description of a schizophrenic's table by French writer and painter Henri Michaux: 'As it stood, it was a table of additions, much like certain

schizophrenics' drawings described as "overstuffed," and if finished it was only in so far as there was no way of adding anything more to it, the table having become more and more an accumulation, less and less a table […] One didn't know how to handle it (mentally or physically) […] the thing did not strike one as a table, but as some freak piece of furniture, an unfamiliar instrument.'[6]

Betraying an indifference to a fixed or practical identity, the schizophrenic's table instead seems to embody an approach driven primarily by the pleasure and satisfaction of joining and connecting its various parts.[7]

That modus operandi seems equally apposite to sculptures by Gelitin, such as *Untitled* [chair] (2008) and *Untitled* [table] (2010), which suggest slapstick orgies of recycled furniture parts joined together in unexpected and manic couplings. In grafting a sense of never-ending, improvised production onto static objects, these works point beyond states of abjection. Like Yuichi Higashionna's 'chandeliers' — chaotic accumulations of banal fluorescent lighting fixtures and exposed wiring — they convey an identity that seems uncanny precisely because it appears to be perpetually sorting itself out (in Higashionna's case this aspect of the work also seems to re-enact the confusions of Japan's postwar culture which included that country's overly-enthusiastic embrace of fluorescent lamps).

*

The interior marks the perspective of the subject, his relationship to himself and to the world. Pierre Bourdieu [8]

In the realm of visual art, the idea of home as one's castle — a sanctuary of seclusion from the outside world — was memorably exploded by Richard Hamilton's 1956 collage *Just what is it that makes today's homes so different, so appealing?* Depicting a home invasion by the mass media and a spectacularised commodity culture (including the camera-ready bodies of its male and female figures), Hamilton's collage exposed a newly interconnected relationship between personal and social space (both physical and virtual). Half a century later many of the artworks in *The New Décor* continue to explore the shifting boundaries of public and private spheres of experience, while taking on the notion of interior environments as staging grounds for our relationships to the world at large.

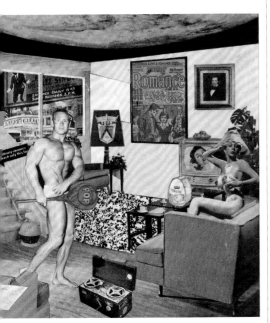

Marc Camille Chaimowicz, whose seminal work in the early 1970s helped to redefine the subject of décor in contemporary art, explores the idea of confidential rituals made public with *Dual* (2006). Comprising two identical pieces of furniture, one posing upright as an austere high-backed chair and the other laid out horizontally as a chaise longue, it suggests a stage set for a psychotherapeutic encounter. Conveying a sense of reversible roles and alternate ways of being that hint at the relationship in this work between furniture and sculpture, as well as viewer and artwork (speaker and interpreter, watched and watcher), Chaimowicz's theatrical *mise en scène* invites us to identify not with one position or the other, but to reflect on the degree to which any identity is a matter of positioning, something we assume through our interaction and exchange with others. Monica Bonvicini's sculptures likewise engage décor as a platform for re-staging

6 Henri Michaux, *The Major Ordeals of the Mind*, Richard Howard (trans.), Harcourt Brace Jovanovich, New York, 1974, p. 126.
7 For further discussion of this reading of the schizophrenic's table, see Gilles Deleuze and Félix Guattari, *Anti-Oedipus*, Robert Hurley, Mark Seem and Helen R. Lane (trans.), Viking Press, New York, 1977, p. 7.
8 Pierre Bourdieu, *Distinction: A Social Critique of the Judgement of Taste*, Richard Nice (trans.), Harvard University Press, Cambridge, MA, 1984.

public and private relationships, but make use of an S&M aesthetic to insinuate the capacity of interior spaces to entrap and constrict. Reworking a sex toy into an architectural intervention, her *Chain Leather Swing* (2009) allows its potential 'users' to make a spectacle of their enchained confinement.

Taking up an art-historical lineage that looks back to Marcel Duchamp's *Door: 11, rue Larrey* (1927), installed between two adjacent doorframes in the artist's Paris apartment so that it could be simultaneously open and closed, a number of artists in *The New Décor* articulate concerns around spatial and social boundaries with sculptures that resemble functional barriers. Tom Burr's *Comfortably Numb* (2009), which takes the form of a hinged folding screen, trafficks in a theatrical double identity by combining references to Minimalist sculpture and sex-club décor, glistening illusion and inert materiality. On one side it presents a glamorous pink mirror, inviting viewers to become both performer and audience, while its other (backstage) side consists of a matt-black plywood surface. Folding screens are typically used to provide partial and temporary privacy in places like hospitals and restaurants as well as living rooms and bedrooms, and Burr's work plays on this contingent character: in the gallery it remains futile as a barrier in any practical sense, hinting instead at an erosion of traditional divisions between personal and public space.

In recent years, both Ugo Rondinone and Michael Elmgreen and Ingar Dragset have fashioned series of sculptures that resemble doors, and implicitly play off their function as apertures that control access between inside and outside. Placed over a gallery wall like a marooned object in an imaginary interior, Rondinone's *lax low lullaby* (2010) presents the façade of a grimly fortified door featuring barred windows. Rather than a testament to urban paranoia, however, it evinces a camp gothic theatricality that hints, perhaps, at a fictional dimension engendered by the gallery's hermetic character, its scrupulous, almost paranoid, shutting out of the external world. Elmgreen & Dragset's *Powerless Structures, Fig. 136* (2002), whose cracked surface seemingly offers evidence of an attempted break-in, wryly raises the possibility of a potential breach in the institutional standards that dictate who and what is included and excluded from the gallery environment — and by extension, any social or cultural institution predicated on principles of inclusion and exclusion.

In raising questions about how we delineate public and private territories, a number of these works recall the furniture-related sculptures made by Vito Acconci from the mid-1970s to the mid-1980s. With works such as *Where are we now (who are we anyway?)* (1976), a ten-metre-long plank that served as a table inside the gallery while extending out of a window to become a diving board suspended above a New York street, or *Maze Table* (1985), an elaborate exercise in mixing up individual and collective seating, Acconci developed forms of sculpture that playfully remixed spatial tropes. In a not dissimilar spirit, a number of sculptures in *The New Décor* suggest hybrid amalgamations of interior and exterior environments. In works as varied as Fabrice Gygi's *Table-Tente* (1993), a child-sized encampment offering shelter from domestic life; Los Carpinteros' twisting commuter throughway of a bed; or Martin Boyce's *Layers and Leaves* (2009), which resembles a folding screen made from park benches, we encounter an incongruous conflating of signs of indoors and

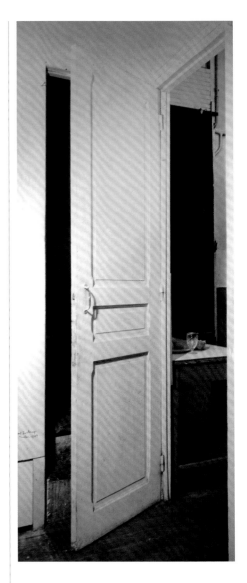

Marcel Duchamp
Door: 11, rue Larrey
1927

outdoors. Bringing together elements of nature and culture, Nicole Wermers' *Untitled bench* (2009) — a display of rocks (each almost large enough to sit on) encased within a Perspex bench — invokes our cultural tendency to contain and domesticate outdoor environments. As if conjuring a reversal of this scenario, Jimmie Durham's *A Meteoric Fall to Heaven* (2000) brings to mind a set piece from a 'nature's revenge' movie: consisting of a small boulder and a wooden chair whose seat it has apparently smashed, this work seemingly testifies to the vulnerability of 'secure' establishments to the unexpected impact of external forces, whether natural disaster or human violence.

*

There is no way of isolating living experience from spatial experience.
Doris Salcedo [9]

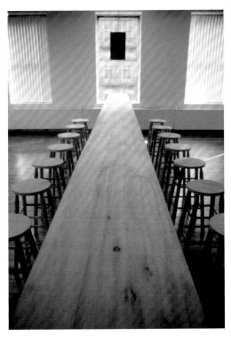

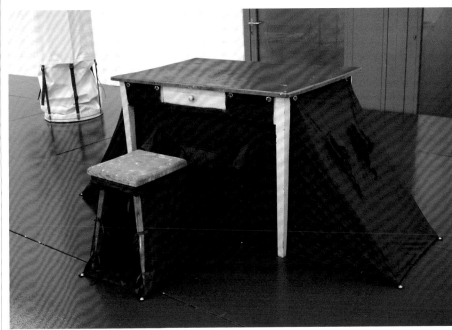

Vito Acconci
*Where we are now
(who are we anyway?)*
1976

Fabrice Gygi
Table-Tente
1993

9 Quoted in 'Interview with Carlos Basualdo', in *Doris Salcedo*, Phaidon Press, London, 2000, p. 17.
10 Walter Benjamin, 'Paris, Capital of the Nineteenth Century', in *Reflections: Essays, Aphorisms, Autobiographical Writings,* Peter Demetz (ed.), Edmund Jephcott (trans.), Schocken Books, New York, 1986, p. 155.

In examining our relationships to public and private space, several artists use décor as a means of intimately evoking socio-political situations in different parts of the globe. Over the past two decades, much of Doris Salcedo's work has grown out of her responses to the traumatic consequences of ongoing civil violence in her native Colombia. Her sculpture *Untitled* (2008) eerily embeds a layer of cement — a material typically used for the shell of a building — in the negative spaces of a pair of wooden cabinets laid out on the floor, and binds them to a corollary pair of tables. If, as Walter Benjamin remarked, 'To live means to leave traces', we cannot help but read the cement infill as the smothering and obliteration of a private life, especially considering the cabinet's domestic role as a case for displaying familial relics and treasured personal objects. [10]

In different works throughout her career Mona Hatoum has evoked what could be called negated or uninhabitable interior spaces, which she has related to the displacement faced by her fellow Palestinians who have lost homes and home-land through Israeli occupation. Highlighting these concerns, *Interior Landscape*

(2008) presents a cell-like room occupied by the barest of furnishings, including a bed of barbed wire and several representations of maps showing the outlines of Palestine (one traced by a hair sewn into a pillow). Hatoum has observed that 'Sculptures based on furniture [...] encourage the viewer to mentally project him or herself onto the objects', yet in the case of *Interior Landscape* this impulse is at least partially derailed by its representation of an explicitly unliveable space (it is not easy to mentally project oneself onto a barbed-wire bed). Allowing us to enter into a 'room' yet keeping us in the position of an outsider, Hatoum's sparsely theatrical work haunts us with a sense of the exile's perpetual alienation. In Jin Shi's installation *¹/₂ Life* (2008), our perspective as viewers is more explicitly voyeuristic: we look down from above into a half-scale simulation of a Beijing migrant worker's impossibly cramped and cluttered dwelling. Like *Interior Landscape*, *¹/₂ Life* deliberately foregrounds the viewer's sense of distance and detachment, using its odd scale to disrupt any impulse we might have to imaginatively occupy this claustrophobic 'room' while conveying the psychological as well as spatial diminishment that characterises the living conditions of millions of China's ill-paid workers.

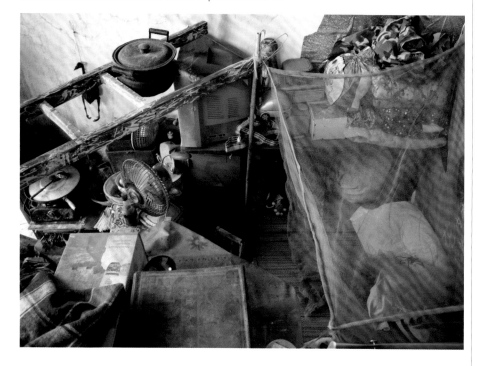

Jin Shi
¹/₂ Life
2008

When it makes allusions to place, sculpture almost inevitably takes on a narrative aspect. Short-circuiting this process, sculptures by Manfred Pernice and Tatiana Trouvé suggest arrangements of décor arrested in an incomplete or nascent state. While their use of recognisable domestic forms and materials intimates a possible utility, works by these artists typically seem unplugged from any fixed point of reference. Like the sculptural equivalent of what anthropologist Marc Augé has called 'non-spaces', these works suggest deterritorialised interiors in which social narratives can only briefly stutter to life, fragment and fade. Rather than merely registering an indifference to identity, their entropic demeanour hints at the open-ended potential of apparent randomness and noise in our environments, re-routing our desire for final conclusions into an ongoing process of speculative interpretation.

Tatiana Trouvé
Untitled
2007

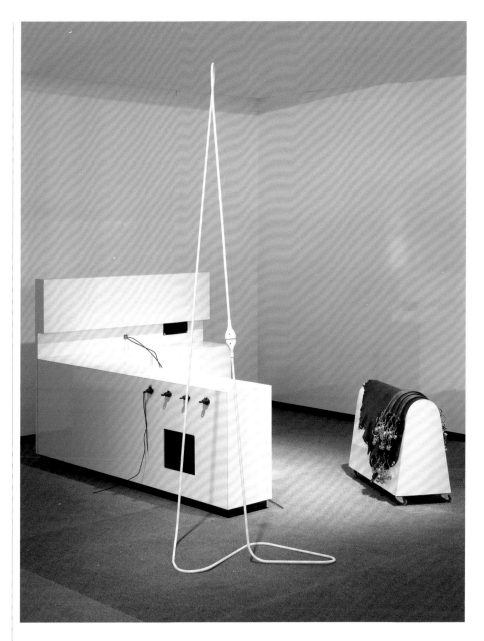

*

The ultimate in paranoia is not when everyone is against you but when every*thing is against you. Philip K. Dick [11]

Is it possible to conceive of a paranoid décor? What would it comprise —
an interior landscape in which mundane objects look back at us with sinister
or unknown intent? According to the late science-fiction writer Philip K. Dick,
the definitive paranoid formulation is not 'My boss is plotting against me', but
'My boss's *phone* is plotting against me'. Perhaps in the case of Urs Fischer's
A thing called gearbox (2004), a painted bronze sculpture that presents an item
of office furniture as a vehicle propelled by violent explosions — we might be

11 Quoted in 'Philip K. Dick: Speaking with the
Dead', an 'interview' by Erik Davis, *21C Magazine*,
vol. 2, 2003.

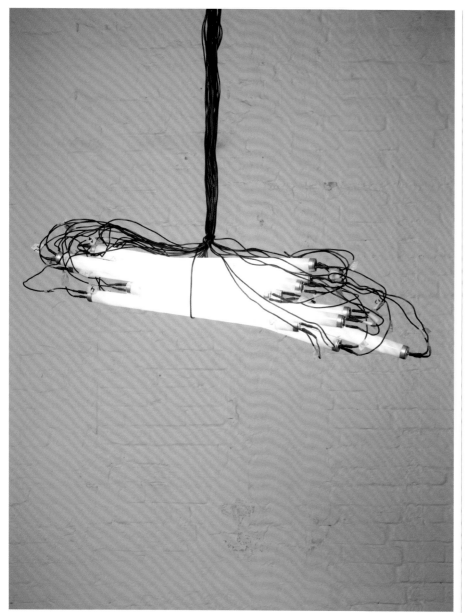

Monica Bonvicini
Kleine Lichtkanone
2009

Raqs Media Collective
A Day in the Life of ___
2009

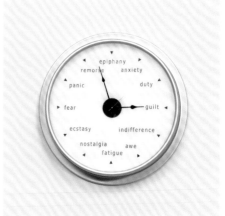

led to imagine our *boss's chair* plotting against us. Given the pervasive culture of paranoia induced by a mass media that relentlessly focuses on fear-inducing subjects (terrorism, crime, contagious disease), even our most mundane daily environments are not immune to intimations of dread. As if underscoring this situation, Raqs Media Collective's *A Day in the Life of ___* (2009) presents a standard wall clock whose numbered hours have been replaced by emotional states, its hands inexorably moving from 'epiphany' to 'anxiety', from 'ecstasy' to 'panic' and 'fear'. A number of other works in *The New Décor* similarly convey ambiguous undertones of threat. The sound of banging from Jimmie Durham's *Close It* (2007), a black metal locker with a tangle of wires dangling from its closed door, conjures a concealed presence, while Nicole Wermers' *Untitled (steel)* (2004) plays off the appearance of security sensors commonly used in shops

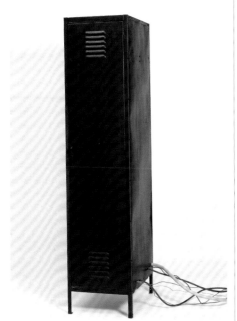

to detect theft, leaving viewers to ponder whether their passage through the gallery is being tracked. More alarming still, Monica Bonvicini's *Kleine Lichtkanone* [*Little Light Cannon*] (2009) consists of a group of neon tubes wired together like a stack of dynamite.

In many ways paranoia is an appropriate narrative model for an age in which all places are connected, in which no effect is purely local, and faraway forces can have a profound impact on our private lives. The works in *The New Décor* highlight this situation in delineating breakdowns and ruptures between our categories of public and personal space. Against the background of a social landscape where 'home' has become a frontline commodity riding the rollercoaster of speculative bubbles, they engage the increasingly exposed precariousness and unpredictability of our everyday environments.

Yet at the same time these works invert paranoid formulations — which concentrate all possible meanings around a single (persecuted) subject — by opening up our reading of sculpture to an expanded field of cultural references and alternative identities. They articulate a conceptual décor in which objects function as generators of ideas about particular kinds of spaces and the relationships they engender, operating from an underlying assumption that space is never neutral or abstract but is always tied to specific cultural frameworks and histories. Ultimately, the content of this kind of work unfolds in the ways that it stimulates us to rearrange our mental furniture, to open new doors and windows in the separate compartments of our thinking — including all those principles of inclusion and exclusion that shut down the range of connections that we make between disparate aspects of social and aesthetic experience. Radically denaturing the appearance of those objects with which we feel most at home, the art in *The New Décor* provokes us to resituate our own position amidst that 'warping of interpersonal relationships' that defines our world of interiors.

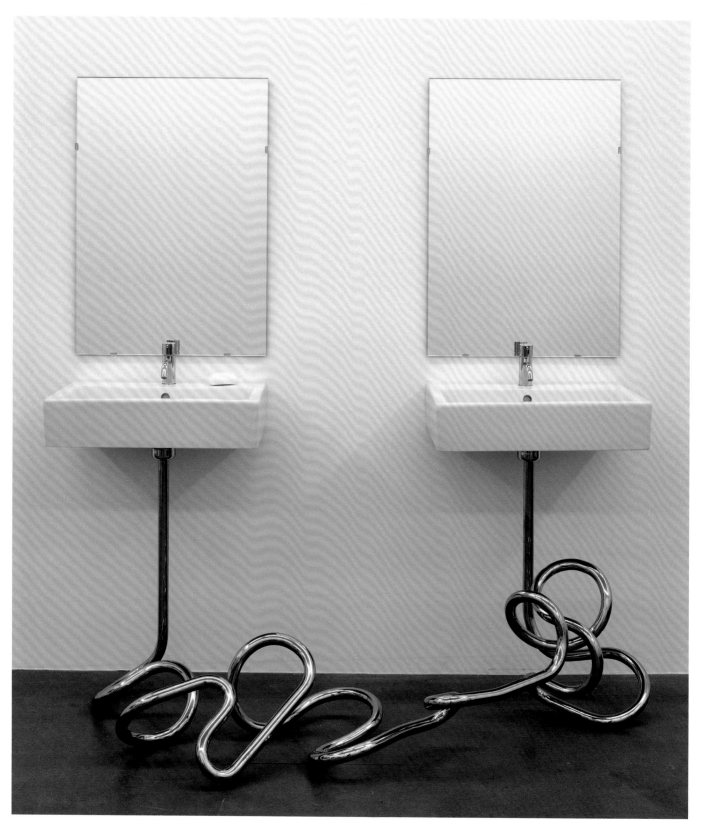

Just what is it that makes today's homes so different, so…?

Hal Foster

The art in *The New Décor* often evokes an everyday object, such as a door, a chair, or a table, only to disturb its usual function or place. Consider the two *Powerless Structures, Fig. 122* (2000) and *Fig. 133* (2002) by Elmgreen & Dragset: two white doors are chained together, and three white doors are nestled within each other, and all are thereby rendered useless. Or take *Marriage* (2010), which consists of two white sinks whose plumbing is stretched, connected and tangled into dysfunctionality. There are strong echoes of Marcel Duchamp and René Magritte here, as well as others who have followed them, such as Marcel Broodthaers and, more recently, Robert Gober and Felix Gonzalez-Torres. Like most of these artists, Elmgreen & Dragset explore ideas of identity and difference in ways that also entail questions of gender. The chained doors recall the famous riddle posed by Jacques Lacan — how does a child tell the boy's room from the girl's room? — and hint that none of us can do so with any certainty, while the linked sinks evoke the Kantian definition of marriage as the reciprocal use of sexual organs by a man and a woman, only to intimate that two of a kind can hook up their plumbing just as well (or unwell).[1] Bachelor machines that do not oppose bachelor to bride, these structures underscore that our usual accounts of identity and difference are problematic, if not powerless. Another piece by Elmgreen & Dragset, *Boy Scout* (2008), is made up of two bunk beds facing each other (the top one is turned upside down), an arrangement that, on the one hand, connotes boy love and, on the other, points to an element of torturous discipline in the formation of proto-military masculinity. Even as such structures represent power as absurd, they do not deny that it continues to operate on us.

Other artists offer up dysfunctional objects, too, such as A *thing called gearbox* (2004) by Urs Fischer, *Bed Head* (2002) by Jim Lambie and *Schwebender Tisch* [*Floating Table*] (2005) by Roman Signer, not to mention the assorted furniture mis-assembled by Gelitin, while still other artists present disagreeable objects in the Surrealist manner of Alberto Giacometti and Meret Oppenheim. For example, Monica Bonvicini spikes her custom pieces — a couch stitched together out of belts and a hammock made up of heavy chains — with a strong dose of S&M (mostly S). Even her cluster of fluorescent fixtures has an aggressive edge — she calls it *Kleine Lichtkanone* [*Little Light Cannon*] (2009) — as do other light works in the show, such as *Some Broken Morning* (2008) by Martin Boyce, a techno matrix of fluorescents on the ceiling. Even the semi-camp pieces involving lights — by Yuichi Higashionna and Spencer Finch — appear a little diabolical, as do such pieces as *Crazy-Nomad-02/Globe-trotters* (2007) by Pascale Marthine Tayou, who possesses some of the divine madness of Isa Genzken.

Elmgreen & Dragset
Marriage
2010

Claes Oldenburg
Soft Washstand
1966

1 Lacan poses this riddle in 'The Agency of the Letter in the Unconscious' (1957) in his *Écrits* (1966), and Kant defines marriage thus in *The Science of Right* (1790).

23

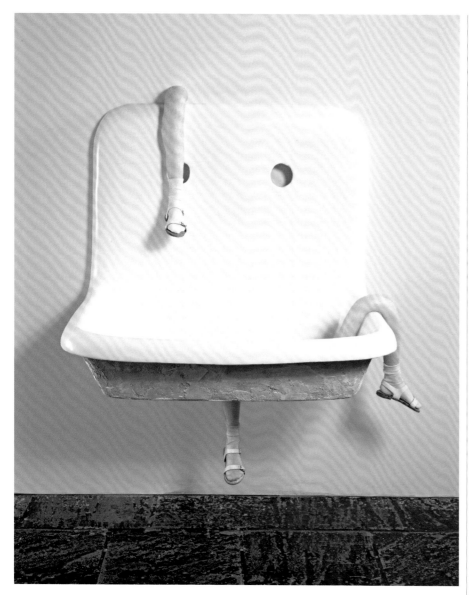

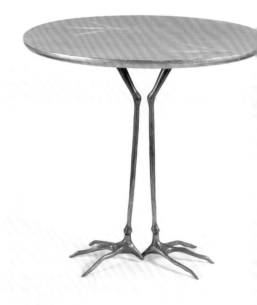

It is Louise Bourgeois who pushed the disagreeable object to the theatrical scale of installation art, and her spirit is also strong in the exhibition. One feels it, for example, in a piece by Rosemarie Trockel, *Table 7* (2008), that that seems to emerge from a grim fairy tale: this white table with two brutal legs suggests a botched metamorphosis. The Bourgeois effect is palpable, too, in *Cama* [*Bed*] (2007) by Los Carpinteros, a bed with a floral blue mattress that not only stretches a vast distance from bedpost to bedpost but also sprouts two bizarre extensions that spiral out like great tongues or snakes, as if this bed were the sleeper transformed by nightmare. Another point of reference for some artists in the show is Claes Oldenburg — not only his performative props from *The Store* (1961) and *The Street* (1960), but also his madcap household items that followed these early pieces. (A less obvious precedent is the semi-anthropomorphic work produced by John Chamberlain in the late 1960s — foam rubber chairs and couches whose undersides and stuffings are exposed.)[2]

Disagreeable objects signal estrangement, which is often born of repression, but here this alienation does not always imply an unconscious, at least not one located in a private subject. For example, Franz West makes sculptures that, like 'the brood' in the David Cronenberg film of that title, appear as crazy impulses made actual in things; indeed, if the curlicue script of his *Sinnlos* [*Senseless*] (2008) evokes an unconscious, it is as a force run amok in the world. This is also true of his well-known *Passtücke* — 'fitting pieces' to be worn or carried by the viewer — which seem like neurotic symptoms that have grown into misbegotten prosthetics.

Some objects in *The New Décor* are less disagreeable than precarious, and so point to a social condition as much as a psychological one.[3] For instance, Thea Djordjadze sets her schematic chair, *Deaf and dumb universe* (2008) — two white slabs, one edged with yellow that backs another edged with green — on

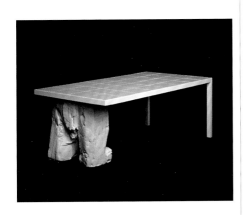

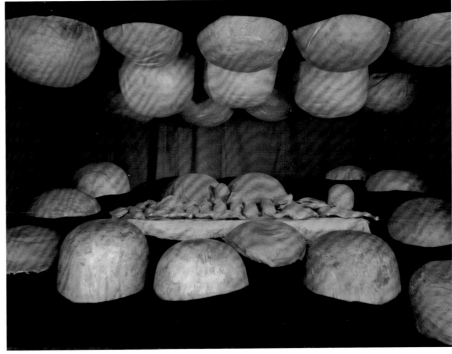

2 Still other precedents might be mentioned. 'Minimal works are readable as art, as almost anything is today,' Clement Greenberg wrote in 1967, 'including a door, a table, or a blank sheet of paper' ('Recentness of Sculpture' in Gregory Battcock (ed.), *Minimal Art*, E.P. Dutton, New York, 1968, p. 183). For Greenberg the Minimalists worked 'the borderline between art and non-art', and so do the participants in *The New Décor*, though this borderline is hardly so guarded today. They also look, more directly, to the eccentric objects of such Post-Minimalist precedents as Eva Hesse and Bruce Nauman. Pertinent, too, is the idiom of Art Povera, which sought, in the words of its champion Germano Celant, to restore 'man-nature identity' through recourse to 'the pre-iconographic'. The art in *The New Décor* betrays no such romanticism, yet it, too, is concerned to 'decivilise' art, and like Arte Povera it prompts the paradox that sometimes to de-aestheticise art is to aestheticise much around it. 'Life is becoming a continuous *tableau vivant*', Celant wrote in the midst of Arte Povera; a visitor to *The New Décor* might feel much the same. See Celant, *Arte Povera*, Electa, Milan, 1985, p. 89.
3 See Hal Foster, 'Precarious', *Artforum*, December 2009.

four spindly legs in a way that presents fragility as a pervasive state of social existence today. In another piece, *Zurück zum Maßstab* [*Return to Scale*] (2009), a bare blue desk, is scarcely able to support itself; as much a sign as a thing, it is difficult to locate securely in our heads, let alone in the world. Beyond precarious, other objects in the show are hapless, sometimes in a humorous way, as if the whole world had turned against them. For example, in *A Meteoric Fall to Heaven* (2008) Jimmie Durham offers a wooden chair that appears demolished by a boulder. Here again an object has become a subject, in this case an apparent victim of cosmic accident.

Other scenarios of violence are less funny. *Fuck Destiny* (2008) by Sarah Lucas consists of tacky furniture that seems to have acted out its own scene of domestic abuse or criminal rampage — a mattress spring bent to the vertical, a couch cushion gouged by a fluorescent lighting tube, a cheap trunk pried open.

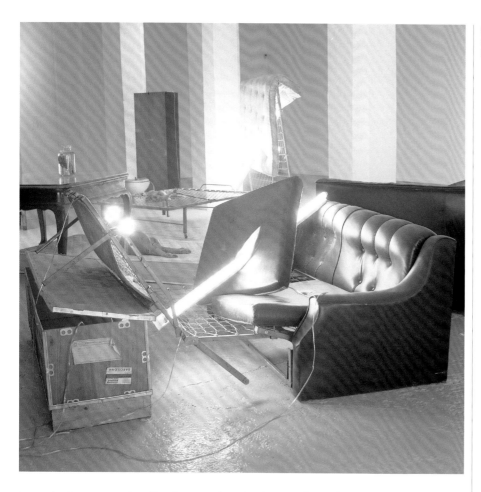

Sarah Lucas
Fuck Destiny
2000

In such pieces construction is very close to destruction, which is also the case, in a more subdued register, of the ensembles of bare desks and chests that are harshly treated yet exquisitely arranged by Doris Salcedo. In her work anonymous objects of everyday life seem to stand as silent witnesses to actual traumas. Her pieces thus appear as testaments to the lost and the disappeared, testaments that cannot yet (or perhaps ever) be read — but that are all the more effective for this grim reticence. Where Salcedo points to losses in the past that live on as repressions in the present, Mona Hatoum intimates events to come. With its stripped bed, tiny table and simple rack with empty net, her *Interior Landscape* (2008) describes a condition of bare life, of life *in extremis* somewhere between the real and the imaginary, that we are invited (almost, it seems, compelled) to enter.

Besides an interior, a décor is also a stage set, and some pieces do suggest fragmentary scenarios, but they are not often ones that invite our participation in the manner of relational aesthetics. As with Salcedo and Hatoum, the scenes to be imagined tend to be bleak — more 'penal colony' than 'utopia station'. Moreover, if installation art once prompted phenomenological interaction with the viewer, there is often a disturbance of connection here, as if the artistic had edged toward the autistic. In any case, much of the work in the show is opposed to the benign phenomenology of, say, Gaston Bachelard. In his influential meditation, *The Poetics of Space* (1958), Bachelard is concerned

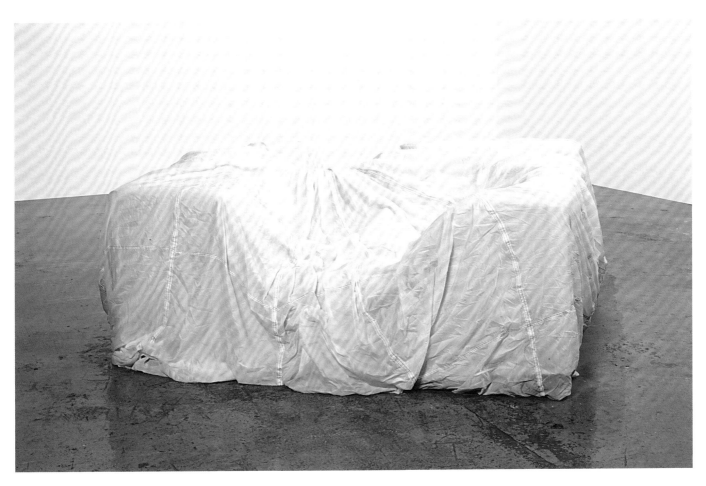

John Chamberlain
Untitled (Couch)
1970—71

4 Gaston Bachelard, *The Poetics of Space*, Maria Jolas (trans.), Beacon Press, Boston, 1969, pp. xxxi, xxxii, 9. Is there an implicit critique here of the faux-phenomenological art that stems from Minimalism — the line, say, from James Turrell to Olafur Eliasson?

5 Yates McKee, 'Neoliberal Gothic', *Texte zur Kunst*, no. 72, December 2008, p. 141.

with 'felicitous spaces' that provide 'the topography of our intimate being', and he sees the house in particular as imbued with 'the greatest powers of integration'.[4] Almost the opposite is the case in *The New Décor*: if there is little sense of the *unheimlich* (the Freudian term we translate as 'the uncanny'), there is almost none of the homey. It is as if subjectivity were so damaged that any restoration through the domestic is impossible: the familiar has become the estranged.

This touches on another inversion often performed here: not only do objects take on the life of subjects, but interiors (in the sense of both subjectivity and space) assume the character of exteriors — that is, they appear turned out, exposed. And sometimes, in this confusion of inside and out, the private becomes a little obscene and the public a little pathological. Certainly the object-world conjured by *The New Décor* does not pretend to be untouched by capitalist reification and spectacle; this is largely why the phenomenology suggested in the show has turned mostly bad, even ugly. At the same time the artists do not often exacerbate this condition in the way of such contemporaries as Rachel Harrison. The critic Yates McKee has pointed to a 'Neoliberal Gothic' active in current art; he describes it as 'a compendium of ruined spaces, severed body parts, uncanny nocturnal reveries and grotesque figures of vampiric predation, apocalyptic madness and impoverished decrepitude'.[5]

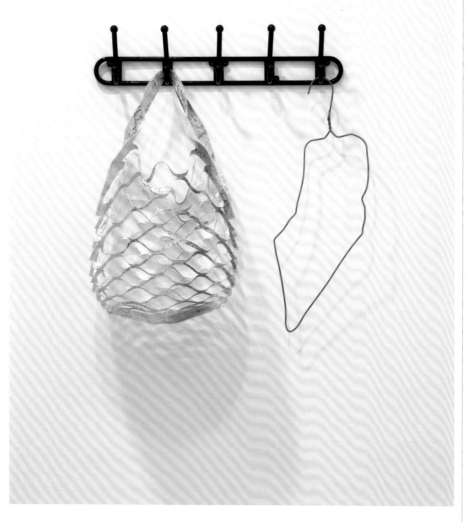

Things are bad in the universe of *The New Décor*, but they are not *that* bad. According to Walter Benjamin, the opposition of interior and exterior, private and public, is an artefact of bourgeois society — of the home developed in opposition to the office. In the first instance this divide was a form of protection. For the private citizen, Benjamin writes, 'the interior was [...] also his casing. Living means leaving traces. In the interior these were stressed. Coverings and antimacassars, boxes and casings, were devised in abundance, in which the traces of everyday objects were moulded'. Yet, as a remove from the world, this divide was also a form of repression, and 'from this sprang the phantasmagorias of the interior. This represented the universe for the private citizen. In it he assembled the distant in space and in time. His drawing-room was a box in the world-theatre'.[6] For Benjamin the Art Nouveau interior, with its elaborate ornament, perfected this excessive interior, but it also promoted the Modernist reaction evident in the glass houses promulgated by the Bauhaus and many others thereafter — houses that 'created rooms in which it is hard to leave traces'.[7]

6 Walter Benjamin, 'Paris — the Capital of the Nineteenth Century' in *Charles Baudelaire: A Lyric Poet in the Era of High Capitalism*, Harry Zohn (trans.), New Left Books, London, 1973, p. 169.
7 Benjamin, 'Experience and Poverty' in *Selected Writings, Volume 2: 1927—1934*, ed. Michael Jennings et al., Harvard University Press, Cambridge, MA, 1999, p. 734.

Art Nouveau found its great nemesis in Adolf Loos, who attacked this 'Style 1900' in several texts a hundred years ago. One attack took the form of an allegorical skit about 'a poor little rich man' who commissioned a designer to put 'art in each and every thing': 'The architect has forgotten nothing, absolutely nothing. Cigar ashtrays, cutlery, light switches — everything, everything was made by him.' This *Gesamtkunstwerk* did more than combine art, architecture and craft; it commingled subject and object: 'the individuality of the owner was expressed in every ornament, every form, every nail.' For the Art Nouveau designer the result is perfection: 'You are complete!' he exults to the owner. But the owner is not so sure; rather than a sanctuary from modern stress, he sees his Art Nouveau interior as another instance of it. 'The happy man suddenly felt deeply, deeply unhappy […] He was precluded from all future living and striving, developing and desiring. He thought, this is what it means to learn to go about life with one's own corpse. Yes indeed. He is finished. He is complete!' For the Art Nouveau designer such completion reunited art and life, with all signs of death banished. For Loos this triumphant overcoming of limits was a catastrophic loss of the same — the loss of the objective constraints required to define any 'future living and striving, developing and desiring'. Far from a transcendence of death, this loss of finitude was a death-in-life, living 'with one's own corpse'.[8]

Today we are in a neo Art Nouveau moment of total design, a 'Style 2000' to match 'Style 1900'.[9] Some of the work in *The New Décor* points to the claustrophobia produced by advanced capitalism in which it seems that everything — from architecture and art to jeans and genes — is treated as so much design, so much data to be processed and reprocessed in an endless circuit of production and consumption. Even as these objects appear damaged by this condition of glut, they act out the damage symptomatically and, in doing so, protest against it symbolically. It turns out that today's homes are not so appealing; they produce their own phantasmagorias of fear and loathing. *The New Décor* is like a prop room in which we can stage some of these fantasies — and perhaps prepare for them if and when they become realities.

8 See Adolf Loos, 'The Poor Little Rich Man' in *Spoken into the Void: Collected Essays 1897—1900*, Jane O. Newman and John H. Smith (trans.)*,* MIT Press, Cambridge, MA, 1982, p. 125.
9 This is an argument made in Hal Foster, 'Design and Crime' in *Design and Crime (and Other Diatribes)*, Verso, London and New York, 2002, pp. 13—26.

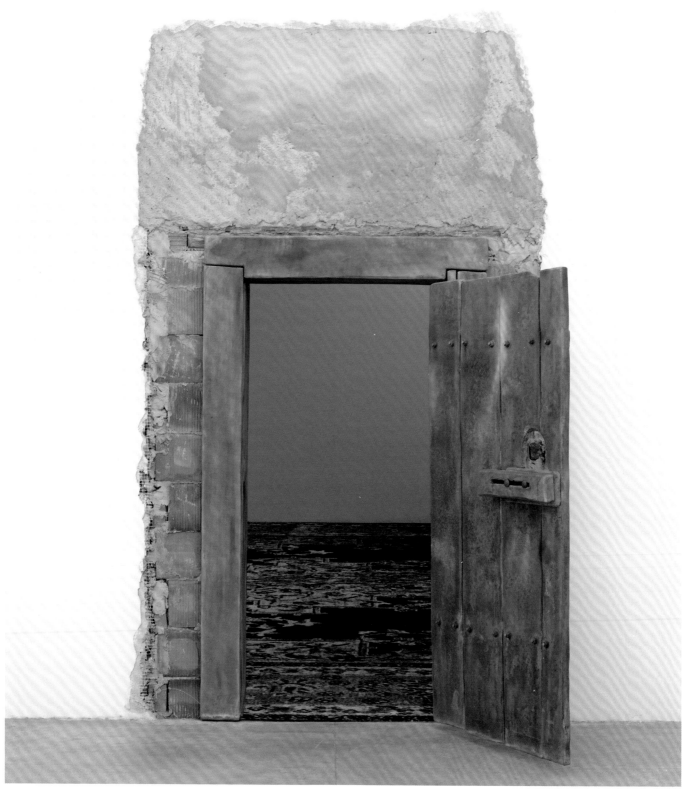

Pattern
Recognition

Michelle Kuo

[T]he thing we were all so blank about was vividly there. It was something, I guessed, in the primal plan, something like a complex figure in a Persian carpet. Henry James, *The Figure in the Carpet* [1]

I just use stuff that's around me. And those objects, those domestic images [...] are made in human scale [...] They speak about us. And they are things you are bound to deal with. Urs Fischer [2]

Decoration is a kind of technology. This might be a surprising claim, since we normally set these terms against one another. A cornice or a curtain, say, would seem to be the very opposite of a computer or a car. But their polarisation is an illusion — a defence mechanism against the deep-seated fear that the useless and the useful are far closer than they appear. In fact, the two have been intertwined since the classical conception of *technê*, which grouped craft, engineering and art all within the same category of making. Such practices were largely defined against *epistêmê* — pure knowledge, that which is true and constant. And this may help to explain the anxiety that grew to surround decoration and technology during the era of Modernism. Both are associated with the supplement: prostheses, appendages external and unnecessary to the work of art or immutable essence. Just as a computer has been seen as an extension of the human mind, the car an extension of the moving body, or the telephone an extension of the voice, so the picture frame is an enhancement of — but not necessary for — the painting. It is for this peripheral, even alien, quality that both the decorative and the technological have been denounced or repressed.

Technology was, of course, a driving force of twentieth-century art. New media and machines were exalted as wondrous augmentations of the body and its perceptual faculties. At the same time, though, technology was opposed as both tool and frill: as instrument of domination and control, on the one hand, and as mere bauble, bell and whistle, on the other. From Arts and Crafts to Art Nouveau, the Werkbund to the Bauhaus, De Stijl to Russian Constructivism, abstract painting to Minimalist sculpture, decoration and technology recur as parallel knots of neuroses. So on the one hand, Modernist architecture argued for function over wasteful ornament, and many of the historical avant-gardes nervously disavowed decadent or domestic embellishment. On the other, craft movements deplored the dehumanising effects of the machine.

Urs Fischer
Untitled (Door)
Rudolf Stingel
Untitled (Sarouk)
2006

1 Henry James, *The Figure in The Carpet* (1896), Le Roy Phillips, Boston, 1916, p. 33.
2 Interview with Massimilano Gioni, *Urs Fischer: Marguerite de Ponty*, exh. cat., New Museum, New York, 2009.

But in their ambivalence — their twin predicaments — decoration and technology converge in ways that are central to modernity. It all began with a pattern: In 1805, Joseph Marie Jacquard introduced his automated loom, which transformed the textile industry. What is more, we can trace the very origins of modern computing to this invention. As has now become legend, Jacquard's loom automated the weaving process, using a programme and its iteration. Cards were punched with holes in specific patterns; the holes allowed the desired configuration of hooks to catch threads of the warp, thereby determining the visual output of the fabric. After seeing the loom, Charles Babbage was inspired to devise his Analytical Engine of 1833, a machine that would likewise use pattern-punched 'operation cards' for mathematical calculations. The Analytical Engine was nothing less than the first general-purpose computer. Yet it had an unlikely analogue. As Lady Ada Lovelace, Babbage's contemporary, wrote: 'the Analytical Engine weaves *algebraical patterns* just as the Jacquard-loom weaves flowers and leaves.' [3]

Pattern becomes programme. Indeed, the connection between Jacquard and Babbage suggests that the entirety of our modern environment — the structures that make up our surroundings, the 'things' we are 'bound to deal with', in Urs Fischer's terms — is based on pattern: on the patterned repetition of serial mass production, and later on digital patterning, without which our designed universe would be impossible. And this link between ornament, technology and automation begins to emerge everywhere in the twentieth century. Even Art Nouveau, often dismissed as a decadent, retrograde cliché of vegetal décor, was actually inseparable from nascent networks of electricity, communication and transport (think of Hector Guimard's designs for the Paris metro), from industrial fabrication, advertising systems, department stores and light engineering. We are very far from William Morris's handiwork when Art Nouveau and its extremely diverse international branches — the *Jugendstil* (New Style), *Sezession*, *Les XX*, and so on — dominate the World's Fair in Paris in 1900, with their peculiarly hybrid display of specialised luxury objects and mass-produced knockoffs. [4] The onanistic, sinuous arabesque, synonymous with Art Nouveau's undulating style, was here subject to repetition and permutation. Its functionless form became a kind of bachelor machine, an irrational automaton.

The patterned template thus paved the way for the iterations of serial production and calculation — what we know as manufacturing, industrial design, media reproductions and circuits of information. But these developments also contributed to the profound confusion between superfluousness and utility in the decorative arts. Art historian Jenny Anger has described such tortured misprisions in the debates over the *Jugendstil*: 'The decorative and ornamental are generally considered to be inessential and functionless. Nonetheless, the decorative arts are supposed to embody a meeting of function and formal qualities in art [...] signifying at once exterior embellishment and an interior, linear structure, a useless arabesque and a useful curtain.' [5] The most infamous salvo in this ongoing dispute was that of the architect Adolf Loos, who condemned the adornments of the *Jugendstil* as profligate and degenerate in his 1908 essay *Ornament and Crime*. [6] Loos's polemic exposed some of the most vitriolic tensions within the idea of ornament: a contest between (meaningless) decoration and (meaningful) abstraction, interior and exterior, impure feminine and pure masculine; the fear that significant form could somehow disintegrate into mere wallpaper, function into futility. Ornament was functionalism's suppressed other.

Jacquard loom with punched cards 1825

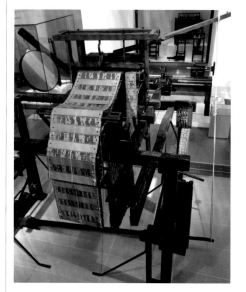

3 A.A. Lovelace, 'Notes by the Translator', in *Sketch of the analytical engine invented by Charles Babbage, Esq. by L.F. Menabrea*, Ada King, Countess of Lovelace, sister of Byron (trans.), Taylor and Francis, London, 1843, in Philip Morrison and Emily Morrison (eds), *Charles Babbage and His Calculating Engines: Selected Writings by Charles Babbage and Others*, Dover Publications, New York, 1961, p. 252.

Richard Riemerschmid
Jugendstil fabric design
1910

This phobia permeated the rise of industrial objects, images and infrastructures in the wake of Art Nouveau and the *Jugendstil*. Ornament grew omnipresent. An escalating world of effects seemed to fulfil the *Jugendstil*'s desire to incorporate the arts into an all-encompassing environment of transience and multiplicity — appropriating public spaces with glittering surfaces and patterns, colour-lithograph posters, big-budget cinema, display windows, lighting, and so on, auguring what art historian Hal Foster has called the 'world of total design'.[7] Decoration was invested with an atmospheric power to shape sensation (finding traction in both turn-of-the-century empathy theory and perceptual psychology). Some saw in this world a terrifying mirror of capitalism's rapacious penetration into every site, every milieu, even mental life itself. And yet, in those

mechanistic and meaningless surfaces, those repetitive formations (what Weimar critic Siegfried Kracauer dubbed the 'mass ornament'), we might have seen something else.[8] We might have found that the old world of manual labour and traditional social bonds was irrevocably gone, but that new and alternate forms of sociality, based not on traditional relationships but within industrial systems and patterns, might be possible.

It was precisely this ambiguity of decoration and technology alike — their deep entrenchment in capitalist structures *and* their capacity to distort or exceed them, their status as both symptom and latent cure — that fuelled the blind utopianism and canny diagnoses of the twentieth-century avant-gardes. Just as the Bauhaus would see the massive proliferation of design as the opportunity

4 Mass-manufactured versions of hand-made Art Nouveau items permeated department stores and restaurants by the time of the Paris Exposition Universelle in 1900. See Rosalind Williams, *Dream Worlds: Mass Consumption in Late Nineteenth-Century France*, University of California Press, Berkeley, 1982, pp. 173—75. This reading goes against the grain of conventional understandings of Art Nouveau as a regressive use of new materials; and it sees decoration and technology embedded well before the Bauhaus would make its celebrated transition from craft techniques to industrial production.
5 Jenny Anger, 'Forgotten Ties: The Suppression of the Decorative in German Art and Theory, 1900—1915', in Christopher Reed (ed.), *Not at Home*, Thames and Hudson, London and New York, 1996, p. 132.
6 Adolf Loos, *Ornament and Crime* (1908), in Ulrich Conrads (ed.), *Programs and Manifestoes on 20th-Century Architecture*, MIT Press, Cambridge, MA, 2001, pp. 19—24.
7 Hal Foster, *Design and Crime (and Other Diatribes)*, Verso, London and New York, 2002, p. 19.
8 Siegfried Kracauer, 'The Mass Ornament', in *The Mass Ornament: Weimar Essays*, Thomas Y. Levin (ed. and trans.), Harvard University Press, Cambridge, MA, p. 76. The essay first appeared in the literary section of the *Frankfurter Zeitung*, 9—10 June 1927.

to transform everyday life, the Russian Constructivists acutely recognised that the serially produced object was becoming ever more dispersed and temporary, subject to consumption, obsolescence, and even transformations into energy (as utilities, electricity and heat).[9] In other words, the object increasingly multiplied and migrated into an ephemeral, circulatory complex: from thing to flow.

<div align="center">*</div>

It was not until the postwar period, however, that this radical reordering of object, system and environment would reach something of a climax. Indeed, this spread of design into nearly every aspect of life was registered and met with alarm by the critic Clement Greenberg, who condemned decoration as 'the specter that haunts modernist painting'.[10] (You wouldn't want to confuse your pathos-ridden Pollock with the horror of machine-made chintz.) And yet this phantom limb was, appropriately, invited into the realms of sculpture, environments, installations, and performance. Claes Oldenburg's early installations, for example, surrounded audiences with fake, distorted suites of bedroom furniture. This experience, as art historian Rosalind Krauss argued in a text devoted to kinetic sculpture and theatre, 'heightens the sense of continuity between the viewer's world and the ambience of the work': the spectator identifies with and as 'the banal objects that fill his space'.[11] Such an inversion of viewer and thing 'cuts […] deeply into an a priorist view of the self, by which the self is thought to be structured, in its most basic sense, prior to experience'.[12] Bodies dissolved into and defined by décor: Oldenburg's interiors highlighted the way in which technology had turned the universe into a prefab backdrop — but they also showed that backdrop moving into the foreground, increasingly defining us, our consciousness, our habits, our existence.

Yet no project of the time turned these tables as brazenly as Andy Warhol's *Silver Clouds* and *Cow Wallpaper*. In April 1966, Warhol unleashed a series of pneumatic, lambent forms that drifted through New York's Castelli Gallery. The kinetic objects made of the aluminised film Scotchpak traced random paths of movement — buoyed by air pressure and currents inside the room. Some simply drifted out of the gallery window. Like Warhol's Factory walls, covered in silver paint and foil, the *Clouds* were all brilliant figure at one moment, dissolved ground at the next. They oscillated between light-emitting body and warped mirror, disrupting the opposition between foreground and background, object and image, the material world versus the specular. And this manic interior was accompanied at Castelli by another room, one lined in Warhol's *Cow Wallpaper* (also 1966) — images of a cow's bucolic gaze, silk-screened in a vertical pattern of garish Day-Glo hues. The filmstrip-like wallpaper was not simply a mural but had actually been printed and installed by a wallpaper manufacturer.[13] This duo of *Wallpaper* and *Clouds* can be read as a devastating critique of both landscape painting and monochrome abstraction.[14] Decoration — the frame or supplement — had finally swallowed the work of art: Greenberg's nightmare. Yet we can also go beyond these pictorial terms (and the attendant context of Minimalism). Indeed, the *Wallpaper* and *Clouds* seemed to flip between the serial, industrially produced ornament and its literal blowup into transient ether. The pair staged the movement from a designed world, founded in the mass production of things, to a décor that had detached itself from the wall: a continuously moving, spectacular atmosphere of images, bodies and screens. Pattern — based on repetition and standardisation — gave way to different kinds of iteration, ones that were more flexible, irregular and disordered.

Andy Warhol
Cow Wallpaper
1966

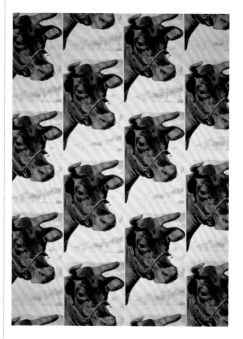

9 On the paradox of mass production as recognised by the Constructivists — 'the more technologically advanced the process of the object's production, the less corporeal, tangible, and objectlike that object becomes', so that processes and systems replaced the object — see Maria Gough, *The Artist as Producer: Russian Constructivism in Revolution*, University of California Press, Berkeley, 2005, pp. 146—47.
10 Clement Greenberg, 'Milton Avery' (1957), in John O'Brien (ed.), *Clement Greenberg: The Collected Essays and Criticism*, vol. 4, University of Chicago Press, Chicago, 1993, p. 43.
11 Rosalind Krauss, *Passages in Modern Sculpture*, MIT Press, Cambridge, MA, 1977, pp. 229—30.
12 Ibid.

Andy Warhol
Silver Clouds
1966

Today, decoration epitomises this transformation of object into system. The world has been remade into sign, into décor. That is to say, décor lies at the crux of the dizzying traffic between industrial processes and digital codes, between the production of tangible goods and streams of information. From a standard-issue, CAD-designed IKEA table to a personalised computer screen, ever more customised surfaces and patterns seem to envelop our landscape. Reading history through surface and ornament is hardly new, of course. Figures from Alois Riegl to Robert Venturi have accorded great significance to ornament, bringing it from margin to centre — whether as a site of formal invention or of symbolic play. Yet such voices are few and far between, and even they would probably have been dumbfounded by the degree to which surface has overtaken structure in the present. For most, this eclipse is more terrifying than exhilarating. It bespeaks the threat of technology run amok, of useless (decorative) kitsch finally obliterating high or advanced culture.

Where critics and historians have feared to tread, however, artists have been more intrepid. Rather than resist or retreat from this intensification of surface and system, pattern and programme, certain artists have faced it head on. The most apt heir to the genealogy I have been tracing would be Rosemarie Trockel — and particularly her brilliant woollen, machine-knit pictures of the 1980s. These works' standardised stitches could, in fact, be read as a droll take on the pixel; their generative code recalls not only Jacquard's punch cards but the raster grid, that infinitely elastic scheme that defines much of contemporary computer graphics. More pointedly, these woven works include patterns based on logos like the Playboy bunny as well as fully abstract monochromes, as if to signal the vast gamut spanned by the flexibility of their warp-and-weft matrix. That scope is charted in the progression from geometry to abjection in Trockel's more recent *Table 7* (2008): a glazed ceramic, steel and wood 'table', its surface scored with a rectilinear grid, which rests on normal legs on one side and a misshapen, prosthetic support on the other resembling a pair of human legs. Or we might see echoes of Trockel's matrices in Angela Bulloch's enlarged 'pixels', sculptural cubes containing fluorescent lights that are programmed to display the precise RGB colour of actual pixels culled from various source images.

Indeed, this welter of production patterns and surface effects raises myriad possibilities for making. Much work today takes up the ensuing detours and unexpected paths, from the humbly hewn to the computer-aided. Martin Boyce works in the very egresses and eddies of this production stream. Contorting commercial materials such as powder-coated steel, ventilation grating and

13 Georg Frei and Neil Printz (eds), *The Andy Warhol Catalogue Raisonné*, vol. 2, Phaidon Press, London, 2002, p. 209.
14 See Benjamin H.D. Buchloh, 'Andy Warhol's One-Dimensional Art: 1956—1966' (1989), in Buchloh, *Neo-Avantgarde and Culture Industry*, MIT Press, Cambridge, MA, 2005, pp. 461—529. On the relation between figure, ground and media in these works, see also David Joselit, 'Yippie Pop: Abbie Hoffman, Andy Warhol, and Sixties Media Politics', *Grey Room* 8 (Summer 2002), p. 75.

fluorescent tube lights, and high design objects such as Eames leg splints and Jacobsen chairs, Boyce mines the gaps between mass manufacturing and custom-made. His 'bins,' precision-made receptacles for nothing, are a case in point. *We are resistant, we dry out in the sun (Small blue bin)* (2004) is a cockeyed, sky-blue rhomboid shell that resembles an axonometric projection gone awry. The scale of a normal rubbish bin, the work nevertheless defies function. Boyce began by sketching a design and then handing over its production to a fabricator, turning out the modular bin in powder-coated steel just as an industrial manufacturer might. The artist did not intervene again until the end, rubbing the piece down lightly with an abrasive cloth to take off some of the sheen.

For *Layers and Leaves* (2009), Boyce turned to a different band of the building spectrum. The work is an undulating divider that recalls Charles and Ray Eames' iconic moulded plywood folding screen. The artist sourced used wood flooring and contracted a carpenter to cut these panels into strips and plane, sand and wax them. He then bolted these slats into vertical, wave-like partitions, so that they mimed the double-sided park benches he had seen on streets in France and elsewhere — only turned on their side. Transmuting one type of décor into another, floor into bench into screen, Boyce just as fluidly reroutes their means of production, from industrially treated wood to custom carpentry to extensive in-studio assembly.

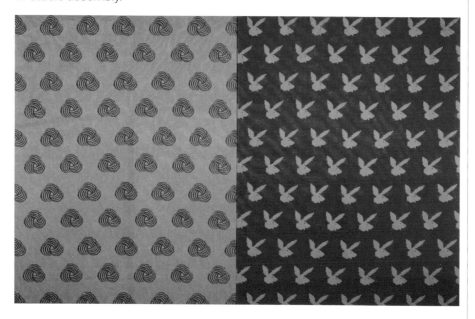

Crossing the precise planes of mid-century Modernist design and Minimalist sculpture (and an accompanying penchant for warped wood and galvanised, tubular and perforated steel) with vernacular fixtures, Boyce reads Pop and Minimalism against the grain. His coy geometry foregrounds the way in which both were actually dependent on specialised and idiosyncratic fabrication processes, not on mass production (whose serial, streamlined look they affected). Today, however, we also know that mass-produced objects are themselves the result of immense resources and long periods of product design, of highly specific and profoundly researched methods. Exception and rule, one-off and off-the-shelf coincide. It is this post-Fordist ramping up of production on all levels that seems potently distilled in Boyce's objects. And this may be why

Martin Boyce
Some Broken Morning
2008

Boyce is so interested in the limitations, life spans and degradations to which objects must eventually submit. If he often modifies preassembled or flat-pack furniture components, then, he also allows preset parameters to determine aspects of the work. In *Some Broken Morning* (2008), Boyce arranged store-bought fluorescent tube lighting in spider's-web patterns that stretched across the ceiling; the lights' readymade lengths governed the dimensions of each piece. These became radiant renderings that specifically echoed the cast of office lighting. Yet these lights are also continually subject to commercial and technological obsolescence: installing *Some Broken Morning* in a different venue, Boyce could not find the same size of bulbs, as they were being phased out in that market. This is a conservation problem, of course, that artists such as Yuichi Higashionna or Martin Creed must all address (estates such as Dan Flavin's have responded by stockpiling the precise type of bulb required when those in use die out). But, moreover, it is a problem of the commodity's ever-growing specialisation and differentiation. There is no one 'generic' light bulb, no ur-typology in existence. The object has become as fleeting as the cold glow it emits.If design is now acutely flexible and contingent (upon technology, consumption, fashion), Nicole Wermers likewise torques its parameters — and the conditions and settings it produces. *French Junkies #5* (2002) is a freestanding ashtray (like those found in lobbies or outside of buildings), complete with cigarette butts lying in its sand-filled vessel.

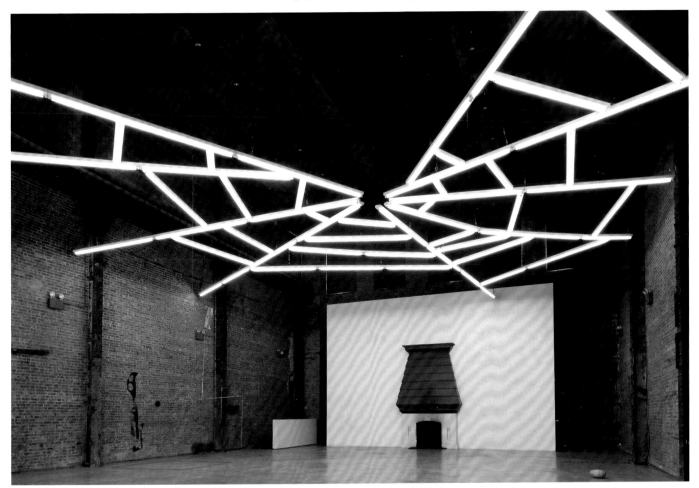

This detritus is countered, however, by a clean white façade of right-angled stripes recalling an Aleksandr Rodchenko mobile or a white-on-white version of a Frank Stella black painting. The shell is actually made of prefabricated aluminium venetian blinds. Functional street furniture turns into an absurd amalgam, physically straddling the hand-made and the machined. The piece also conforms to the grid or deductive structure — a scheme in which internal shapes are determined by their surrounding frame (rectangles inside a rectangle, for example). Here, not coincidentally, figure is indistinguishable from ground.

Wermers' other works, such as *Untitled (steel)* (2004), are decidedly more sinister. They recall the portals of shoplifting detectors in store doorways, prosthetic armatures for surveillance systems. Fabricated in stainless-steel diamonds and arcs implanted in the floor, the sculptures simultaneously echo and evacuate electromagnetic fields of control. They powerfully divide space with an economy of means (as a Fred Sandback string sculpture might), but they imbue that space with palpable power relations as well. There could be no more succinct staging of the frame, the border, taking over the whole. Wermers' wall-size tableaux based on the weather-resistant aluminum panels used underfoot in commercial buildings and loading ramps are just as foreboding. Their shiny monochrome surfaces are inflected by raised leaf-shaped abstractions; these forms are based on the characteristic skid-proofing relief patterns of their source material. While the puckered speculums of Warhol's *Silver Clouds* deformed the Minimalist cube and its reflexive reference to its space of display, Wermers' metallic panels give back a smeared, obscured mirroring. Their obdurate surfaces do not seem to reflect so much as absorb their surroundings. These inanimate façades and porticoes seem to be watching us, rather than the other way round.

Interior surfaces also come to eerie life in the work of Marc Camille Chaimowicz. Not only does the artist actually design 'real' wallpaper, thereby conjuring a lineage of ornamental coverings from Art Nouveau to Warhol to Franz West, he also fabricates intricately patterned carpets and upholstery. These filigreed furnishings take centre stage in the installation *Dual* (2006), which comprises a chair, chaise longue and wallpaper, each sporting ornate abstractions. The elongated, pointed curves of the chairs' frames and their fabrics are, in fact, based on *Jugendstil* patterns; and upon closer inspection, the 'chair' and the 'chaise' are actually identical in structure, merely oriented differently: the back of the chair stretches down to the floor, and is in fact the sloping divan of the chaise when turned. Such entities invert both function and form. And coupled with the wallpaper, which is in this instance stretched onto picture-like panels (making Greenberg, not to mention Loos, turn in his grave once again), the scene creates a claustrophobic psychological space, a *horror vacui* of pattern that would seem menacing were it not for its kitsch pastel palette. By no means, though, does this blunt Chaimowicz's edge: echoing the *Jugendstil*'s encroachment into everyday life, these patterns seem to creep along the wall and the floor, physically enacting the spread of décor over and above the surfaces of experience. So, too, the artist's crossbred chair-sculptures and textiles perform the convergence of specialised object and mass-produced ware, a junction that began with Art Nouveau and the *Jugendstil*, and which seems to have found its apotheosis here.

From repetition to singularity, supplement to centre: perhaps no artist has intervened in these shifts as aggressively and astutely as Urs Fischer. Rather than attempt to recover art's lost innocence or withered autonomy, Fischer

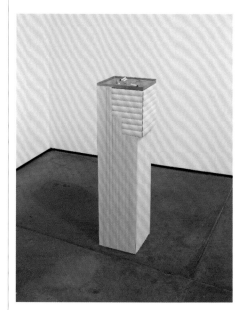

Nicole Wermers
French Junkies #5
2002

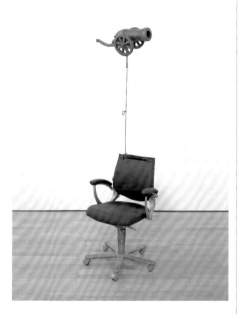

actively plunges into the compromised fields of product design and surface decoration. With both finesse and brute gesture, he modifies chairs (from the desk variety to the domestic), jury-rigs prosthetic limbs to twitch mechanically, and suspends a polycarbon cake in a magnetic field. In *A thing called gearbox* (2004), he takes one of these desk chairs and warps it slightly, then suspends a small metal replica of a cannon over the chair — but 'attaches' this curio to the chair with a string, so that it appears to be floating, even though we know this should be impossible. One of several such sculptures that prompt this illusion, the work trumps even Oldenburg's fantastic furniture. Fischer brings mundane and peripheral objects into a near-animate state, pitting what we know of materials and densities against what we see.

Even more ambitiously, Fischer has torn through the structures of display with a winking élan that would have scandalised Gordon Matta-Clark. He has sawn holes in the exhibition walls of the Kunsthalle Zurich and Whitney Museum alike; he dug a hole, scanned and made a cast of its negative space that was then shown breaking through the ceiling of a gallery. He (or, rather, his construction team) has even committed the wholesale excavation of an entire gallery, in the notorious *You* at Gavin Brown's Enterprise in 2008.

Besides bulldozing them, Fischer has also punctured exhibition spaces with provisional entryways cut into walls, their painted 'stone' and 'wood' frames resembling the rustic peephole portal of Marcel Duchamp's *Étant Donnés*. And like Duchamp's work, Fischer's *Untitled (Door)* (2006) elicits a startling response. At the Hayward Gallery, it is installed as a gateway to a 1960s-era service lift not normally accessible to the public; here, the lift can be entered by viewers, but does not go anywhere. The door is an irruption into the gallery's white wall, a mirage of stone masonry that leads to a dead end, a chain of sleights of hand. Like Fischer's other interior-surface works (*trompe-l'oeil* wallpaper, kinetic mirrored walls) *Untitled (Door)* stands at the knife-edge between figure and ground, heightened perception and prosaic routine.

This is the province of decoration — the pattern that goes overlooked until it is suddenly and ubiquitously seen, only to dissolve once again into the background.[15] It is also the experience of the tool: what Martin Heidegger saw as the equipment that forms our environment, that surrounds us unperceived, until it breaks.[16] Indeed, these switches in attention have everywhere become the norm. The strange beauty of Fischer's project is that it acknowledges these conditions, dexterously releasing this world within the very setting most determined to keep it at bay: the museum. It is only fitting, then, that in his 2006 show with Rudolf Stingel at Galleria Massimo De Carlo in Milan, Fischer installed *Untitled (Door)*, along with other versions in varying materials and styles, perforating the galleries in a labyrinthine sprawl. These thresholds opened onto rooms covered with Stingel's elaborate floral carpeting, expanses of scrolls and blossoms. And, finally, hovering over one area of this embellished floor was a small pack of Camel cigarettes, twitching in an erratic circle, guided by a virtually invisible nylon filament. This was Fischer's *Nach Jugendstil kam Roccoko* (2006) — an intentionally misspelled title that could otherwise be translated as 'From *Jugendstil* to Rococo'. It is as if the ordinary cigarettes, now animated as a limping, useless contraption, were condemned to cycle through all of the degenerate and florid forms that comprise Modernism's bad dream. But we could also see the object tracing another figure in the carpet, one whose path we could not exactly predict.

15 As Christine Mehring has argued, '[Decoration's] phenomenological use depends on hyperawareness of the unfamiliar, its banal use on a familiarity that goes almost unnoticed; one use refers to a climax of criticality, the other to the epitome of complacency'. Christine Mehring, 'Decoration and Abstraction in Blinky Palermo's Wall Paintings', *Grey Room* 18 (Winter 2004), p. 98.
16 Heidegger writes, 'When we discover its unusability, the thing becomes conspicuous'. Martin Heidegger, *Being and Time*, Joan Stambaugh (trans.), State University of New York Press, Albany, 1996, p. 68.

Monica Bonvicini

Kleine Lichtkanone [*Little Light Cannon*] (2009), as its name suggests, is no ordinary overhead lamp. It neither envelops its surroundings in a warm cosy light nor serves as a decorative centrepiece. Constructed from neon tubes slung together and cinched at their middles with a single black wire, Bonvicini's lamp hangs precariously above our heads, dousing us in a shocking harsh white light. It may be reminiscent of Dan Flavin's Minimalist sculptures made from neatly arranged neon tubes, but the gesture of Bonvicini's DIY arrangement, with its chaos of tangled wires plugged into fuses at the ends, is more reminiscent of the act of throwing together a makeshift bomb.

This aggressive configuration is characteristic of Bonvicini's sculptural interventions, which are uncompromisingly direct responses to architectural spaces that she sees as being designed by and for men. Using primarily industrial building materials, including metal bars, chains, plywood, plaster and drywall, she designs sculptures that provocatively reconfigure the rooms in which they are placed.

Chain Leather Swing (2009), a hybrid utilitarian object, is a hammock slung from the four corners of the gallery space by metal chains, converging in the middle of the room to form a seat that does not so much invite relaxation as dare you to enter its tangled web. Similarly, *Belts Couch* (2004), a reclining lounger built for two people but woven from thick black leather belts, evokes instruments of bondage while toying with the promise of conventional domesticity. Both items cause us to pause before them, hovering between curiosity and desire, intimidation and fear.

CL

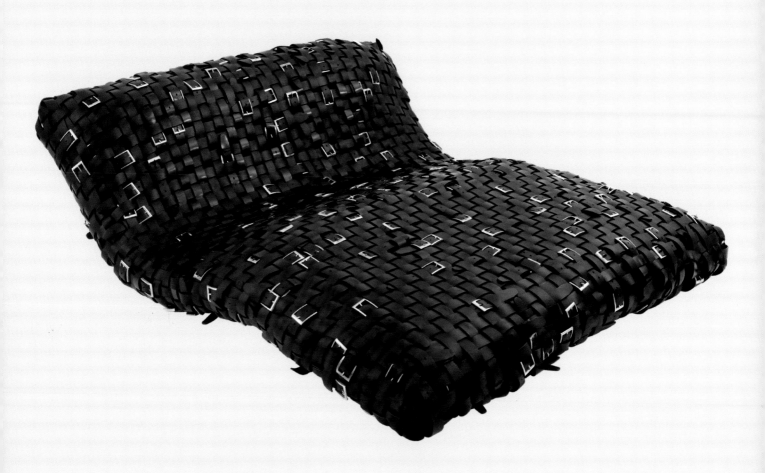

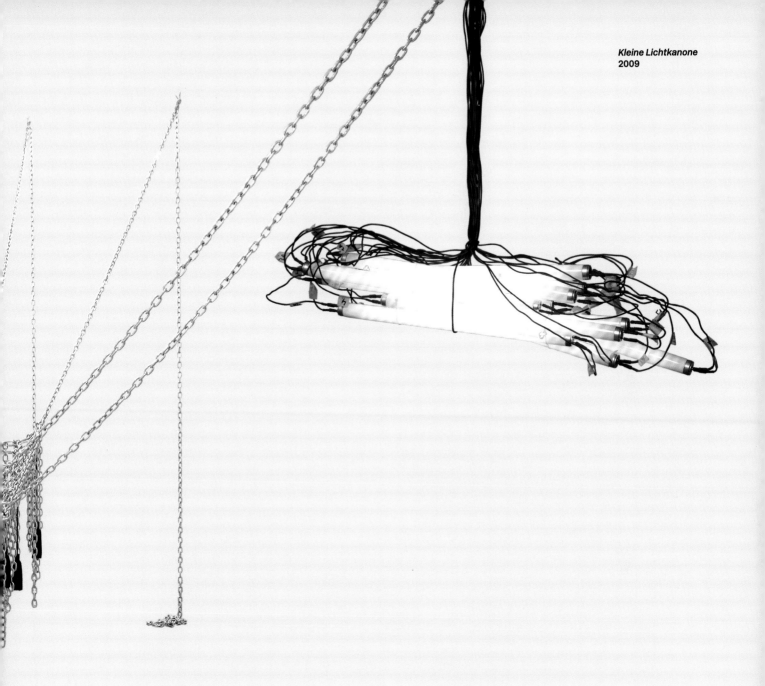

Martin Boyce

'Can I make a table sad or heavy or exposed and lost?' wonders Martin Boyce. In his sculptural installations the artist imbues Modernist urban furniture with characteristics that transcend their original forms and functions. He imagines rubbish bins as objects 'marooned in an imaginative landscape', like his *We are resistant, we dry out in the sun (Small blue bin)* (2004), which shifts the central axis of a typical, functional metal trash bin, such as you might find in a public park or pedestrian zone, into a dynamic, diagonal sculptural object.

Layers and Leaves (2009) comprises several typical wooden park benches turned upright and connected to form an undulating, accordion-like screen. The benches can neither fulfil their original function as places for relaxation nor their new role as a screen, because of the gaps between their wooden slats. The work was originally part of Boyce's installation for the Scottish Pavilion in the 53rd Venice Biennale, located in a fading fifteenth-century palazzo. Here, Boyce imagined an abandoned garden with concrete stepping stones in an evaporated pond, fallen leaves underfoot and geometric chandeliers overhead.

Some Broken Morning (2008) is a floating lattice of neon tubes, suspended above our heads. This fractured, fluorescent expanse forms a spider's web of light that Boyce sees as a distortion of the city grid — an urban plan that has been twisted out of shape in order 'to slow it down'. The work is characteristic of the way that Boyce extracts elements from their original contexts and gives them abstracted forms. Liberated from their original purpose, they can be seen as symbols of the shortcomings of Modernist design, or given new possibilities to achieve their utopian objectives.
CL

We are resistant, we dry out in the sun (Small blue bin) 2004

44

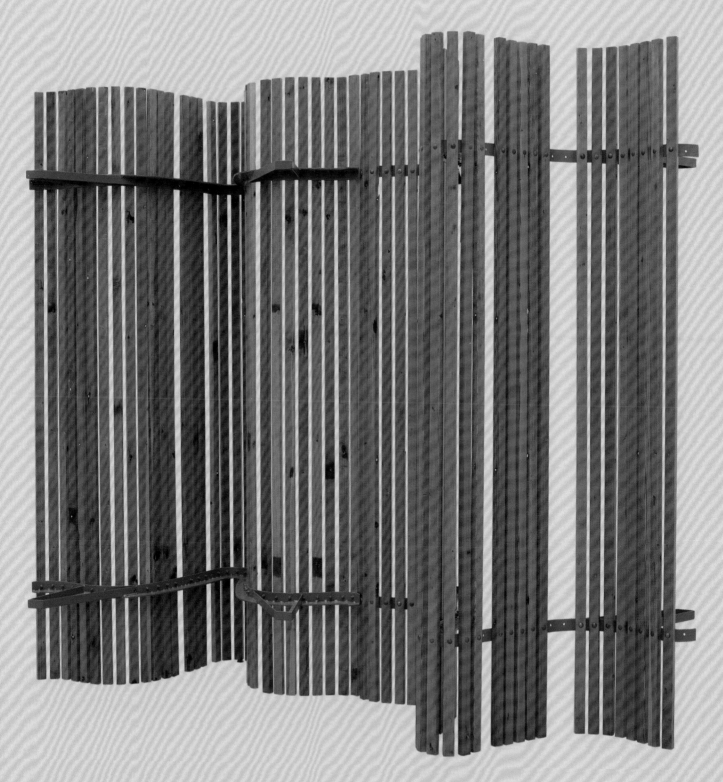

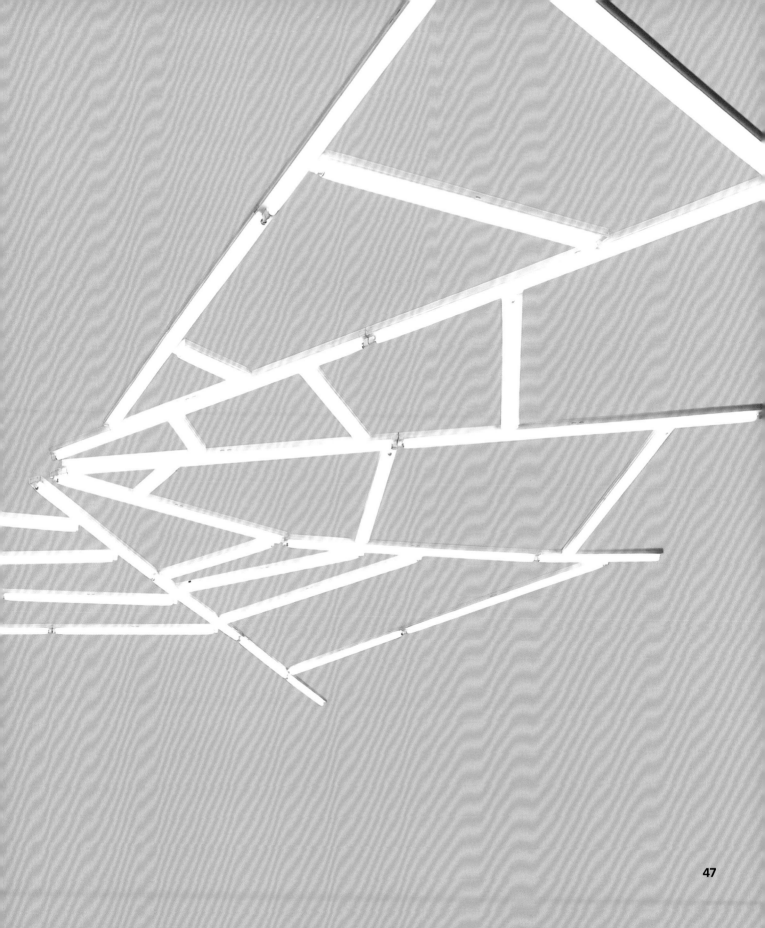

Lee Bul

While Lee Bul once explored a post-human world through eroticised Cyborg-sculptures, in recent years she has looked back to an earlier age's dreams of the future as manifested in architectural forms. The Weimer-era architect and visionary Bruno Taut has particularly inspired the Korean artist's works. Bul's series of chandelier-like hanging sculptures explode the forms of Taut's prismatic *Glass Pavilion* (1914) with its twisting dome and pineapple shape. In *Sternbau No. 3* (2007), curving steel arms are decked with crystal, glass beads and steel chains. Resembling a fantastical cathedral in the air or mountain peaks glittering with ice, the hanging sculpture also points to Taut's *Alpine Architektur* (1919), in which he imagined a series of crystalline architectural structures that would stretch across the Alps. While Bul's sculpture might be seen as a homage to Taut, as with her earlier pieces featuring sexualised mutations of human and technological forms, her work with architectural motifs and abstract sculpture has a double-edged appeal.

Sternbau No. 3's sense of beauty run riot, or sprawling baroque decadence, subtly captures something of the flipside of Modernism's utopian project, the desire for an impossible 'perfection' manifested in Nazism, for instance, as both disastrous and seductive. This sinister aspect comes to the fore in other works where Bul has referenced South Korea's more recent, traumatic path to modernity. Her installation *Heaven and Earth* (2007) for example consists of a bathtub set in a sharp-edged concrete block covered with chipped white tiles. Clinical and shabby, it could easily be a place used for torture. Surrounding the edge of the bath is a sculpture of Baekdu Mountain, the mythical birthplace of the Korean nation. Realised in pure white, its jagged peaks are reflected in the black ink that fills the tub, uniting the beauty and horror seemingly inherent in world-changing projects.

ss

Angela Bulloch

Since 2000, Angela Bulloch has been manufacturing her 'pixel boxes', elegant cubes of birch or aluminium housing three coloured fluorescent tubes behind opaque glass. The boxes, designed in collaboration with the artist Holger Friese, are connected to a sophisticated DMX modular system, which allows Bulloch to choreograph the changing light colours. The combination of just the red, green and blue tubes inside each box can generate more than 16 million different hues.

Bulloch designed the pixel boxes to resemble 'pieces of vintage hi-fi equipment', leaving their circuitry exposed at the back and copyrighting each unit, marking it with a serial number. Arranged in lines, stacks, grids or standing alone, each pixel box functions as both monitor and lamp: it can be a source of atmospheric light for a room, but there is nothing arbitrary about the modulation of that light — each work is based on individual pictorial information that Bulloch extracts from film or video footage. In the case of *Extra Time 8:5* (2006), the colour changes are based on single pixels abstracted from the BBC television show 'Extra Time'. In this work, Bulloch recreates the domestic lull of the glowing TV screen, but she renders its images indefinable and its programme illegible.

In the wall-based work *Smoke Spheres 2:4* (2009), the arrangement of lights is also not merely decorative. Rather, the placement of the 19 illuminated smoked-glass spheres is based on the composition of black circles on white canvas in Bridget Riley's 1964 Op-Art painting *White Discs 2*. Though *Smoke Spheres* does not formally resemble the pixel boxes, its structure is similar, in that Bulloch transposes one apparently 'random' arrangement into another. The modulating light and fading colours in Bulloch's light-based works, sometimes accompanied by commissioned soundtracks, is not that of a 'mood lamp' or 'lounge music'; instead, Bulloch renders the domestic or communal act of watching TV or 'chilling out' unexpectedly inscrutable.
CL

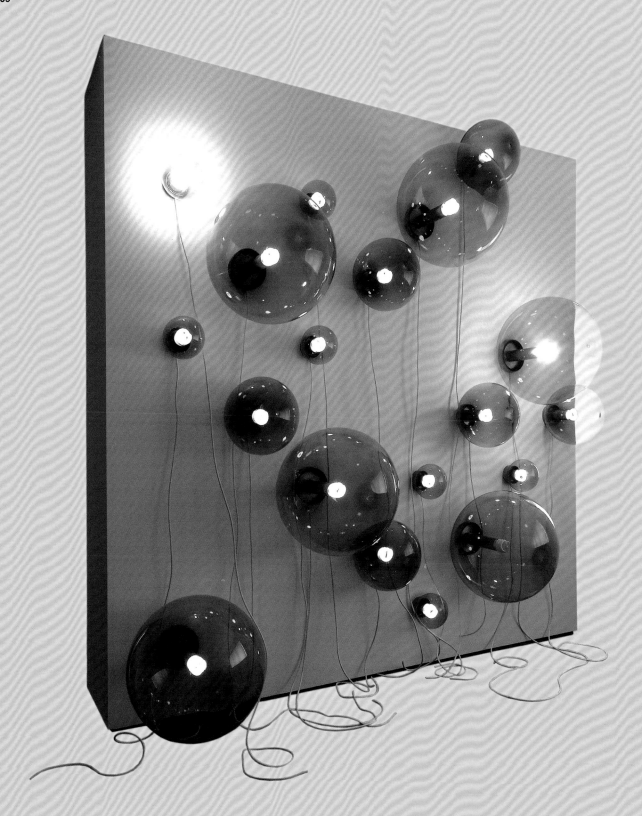

Tom Burr

Since the early 1990s, Tom Burr's work has brought the hard-edged aesthetics of Minimalism down to earth by insisting on its similarity to things we know, such as furniture, suburban architecture and interior design. He switches the industrial materials and large scale of the high-art originals for more manageable variants, while the neutrality of their precise geometry is rejected in favour of subjective associations with design, leisure or sexual politics.

In *Black Box* (1998), Donald Judd-like cubic wooden constructions are split into sections, painted black and fitted with mirrors and ledges, conjuring up dark basement bars. These resonances become even more explicit in *Black Out Bar* (2003), where a monolithic black block becomes a bar littered with half-empty glasses and overflowing ashtrays, while black bar stools and flower-shaped vinyl cloths lie about in disarray, picturing the morning after a heavy night.

Burr has spoken of wanting to develop a sculptural practice that could 'simultaneously incorporate a concern with audience and site specificity, with thoughts of subjectivity, sexuality, and autobiography'. He has a theatrical approach to furniture, making furniture-like objects which are then staged in set-ups rife with narrative allusion or subjective reference. By engaging these external influences, the structures Burr creates appear as sites of experience that demand a personal response.

The hinged folding screen *Comfortably Numb* (2009) has a human scale, like the kind of domestic paravents behind which one dresses, or undresses. One side is painted matt black, recalling what has been termed the 'hyper-masculinity' of Minimalism and the sex-club aesthetics of earlier works, while the other is clad in high-camp pink Perspex mirror. This sculpture seems to have a split personality: part prudish protector, part tantalising sexy prop. But its hinged structure also means it is collapsible and moveable, lending it an instability that privileges temporary experience over monolithic statement and performance over inertia. The mirrored surface integrates the audience literally while insisting on the gallery as a socially, or even sexually, loaded space.

KB

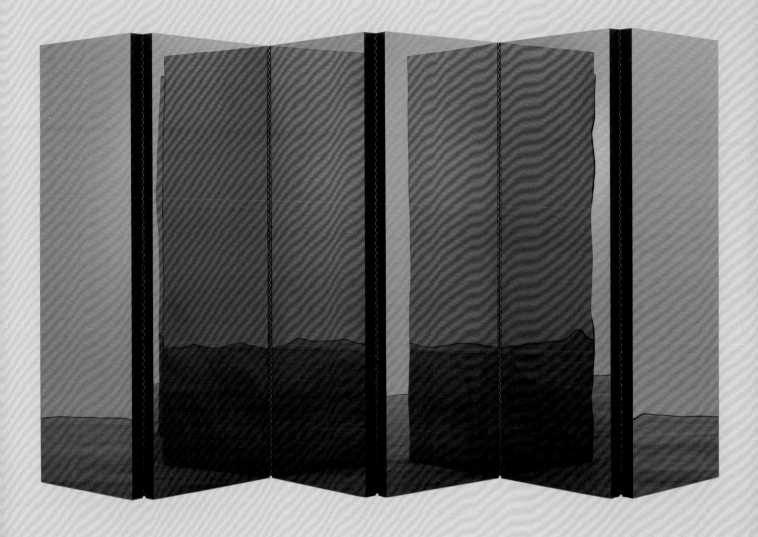

Los Carpinteros

Los Carpinteros ('The Carpenters') make work that inverts the function of interior spaces and the objects within them, employing metaphor to raise questions of politics, identity and national culture. Comprising the Cuban artists, Marco Castillo and Dagoberto Rodríguez, the duo's practice places a value on collective working, subverting the notion of the individual artist as genius in an age of mass production. Earlier works such as *Torres de Vigilia* [*Watch Towers*] (2002), large metal lookout posts that one could climb, developed a nuanced engagement with the architecture and space of the gallery, turning the tables on what visitors looked at. Behind the polished, almost anonymous aesthetic to their work, there is an underlying critique of commodity that might be an echo of Cuba's ongoing struggle for identity and its fractious relationship with the United States.

In creating hybridised furniture, Los Carpinteros fuse the fantastic and the everyday, breaking open a realm between the pragmatic and the imaginary. With *Cama* [*Bed*] (2007) they present a bed that has been customised into the shape of a motorway junction, complete with flyovers and slip roads. One cannot help but think of this in the context of America's fascination with the automobile. The freeway overpass is an architectural landmark, a feat of structural engineering, each one an anonymous homage to the freedoms afforded by road travel in that country. And yet this homage is here supplanted in a bed, a place of rest, sleep and love.

The bed as a domestic site was similarly explored in *La Montaña Rusa* [*Russian Mountain*] (2008). This time a pink version was reconfigured into the form of a rollercoaster. In both works, such juxtapositions are at once seductive and monstrous. They might be trumpeting the extrapolated whims of a consumer society, but equally they could be an ironic upturning of commodity in a globalised economy. It is unclear where the celebration starts and the criticism ends.
RP

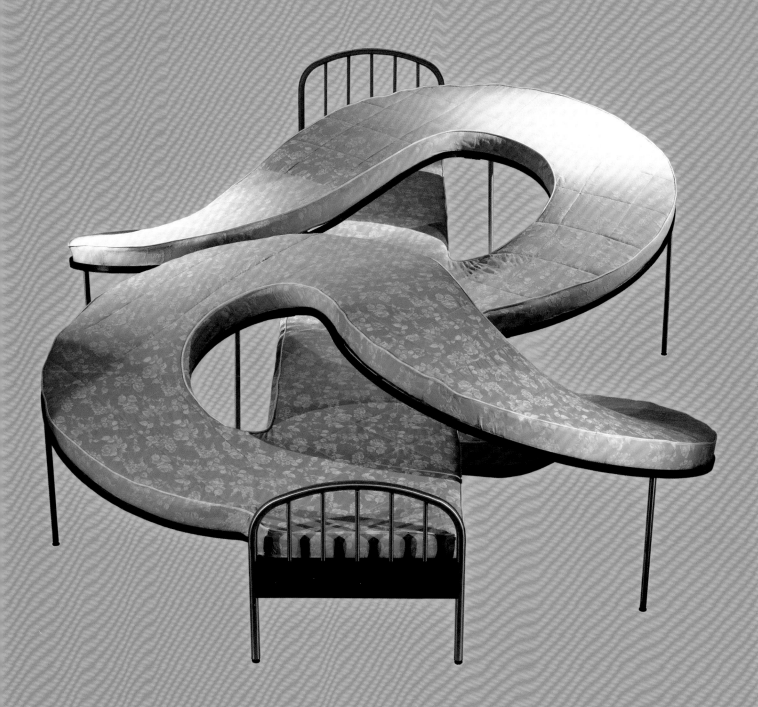

Loris Cecchini

Loris Cecchini's work develops the possibility of parallel realities around everyday objects. The curvy white seat at the centre of *Relativistic loop corrections to the chair function 1* (2007), still serves its original purpose. It can be comfortably sat upon, but little else about it resembles an ordinary piece of furniture. A cloud of small white plastic balls supports the seat, as if molecules had been rendered visible and we were watching the material world atomise and change shape before our eyes. As the viewer circles the work, its mass of bubbles and air seems to shift. Outlines blur and a sense of weightlessness counteracts the appearance of bulk as forms expand and contract. Indeed, it seems to breathe. Yet, while the work may look biomorphic, its materials (chiefly polytetrafluoroethylene modules) are evidently man-made, the product of a complex chain of production involving science, design and industry. As Cecchini collapses the distinctions between the natural and artificial, our relationship to the world of objects is further unbalanced.

Cecchini has long explored the fluidity between things, breaking down the usual categories of perception. Man-made materials are employed to a somewhat different effect in earlier works like *Stage evidence (untitled)* (2001). Here a desk, computer equipment and typist's chair are cast in droopy white rubber. These simulacra are materially all of a piece, and appear to sag towards the floor as if both their practical and metaphorical use had been exhausted. How we interpret the world becomes uncertain as furniture and office paraphernalia are reduced to a rubbery outline that can only gesture towards a former function. In *Gaps (chair)* (2004) divisions between things similarly give way, as a gallery wall bulges out cancerously to enclose and morph with a folding chair. These pieces feel decidedly earthbound in comparison to the artist's more recent molecular abstractions, which suggest a process of incessant transformation.

ss

Marc Camille Chaimowicz

In Marc Camille Chaimowicz's work since the 1970s, boundaries between art and life are continually renegotiated, preventing the strict separation of the two. For several years his flat in Bethnal Green was the site of an ongoing aesthetic exploration, in which the rituals of daily life assumed exaggerated importance, while the domestic interior became a set-like apparatus for the staging of an assumed identity. Elements from this idealised home were then taken into the gallery, challenging a public/private divide. For the exhibition '...*In the Cherished Company of Others...*' (2004), Chaimowicz created an imaginary apartment for Jean Cocteau, designing a *mise en scène* in which to accommodate his own sculptures, furnishings and wallpapers, as well as works by other artists.

Bibliothèque (pink) and *Bibliothèque (green)* (both 2009) are typical of Chaimowicz's ambivalent but charming sculptures, which approach the functional but resist the banal. A pair of bookshelves with Art Deco-like stylised details, delicate colouring and feet like pairs of inverted commas, becomes almost a stand-in for the artist himself, establishing an intimate relationship with the viewer, the carefully chosen books seeming to suggest topics for a conversation. Here, the books on one set of shelves include several dummy volumes bound in Chaimowicz's signature patterned motifs, while the other remains empty, ready to accommodate whatever ideas the viewer brings. Chaimowicz's fusion of furniture and sculpture suggests an interest in a work of art whose identity is not fixed, but rather open to inflection through usage, with an inherent versatility of meaning.

This is quite literally the case with *Dual* (2006), two elegantly sinuous plywood constructions covered with hand-printed *Jugendstil*-patterned fabric, that can be placed either upright as a high-backed chair or horizontal as a low couch. First shown in Vienna, they are the perfect post-Freudian furnishing, ready for either analyst or analysand. While this implies something of the 'dual' identity of the individual, both ready to speak and ready to listen, it also relates to the artwork's implication of two individuals: the maker and the viewer, the giver and the receiver, suggesting again the work's role as instigator of some kind of exchange.

KB

Dual
2006

Customised décor
2009

An Elliptical Retort...
2009

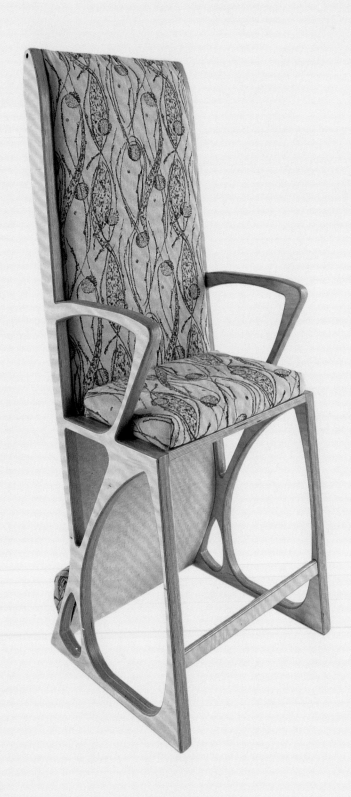

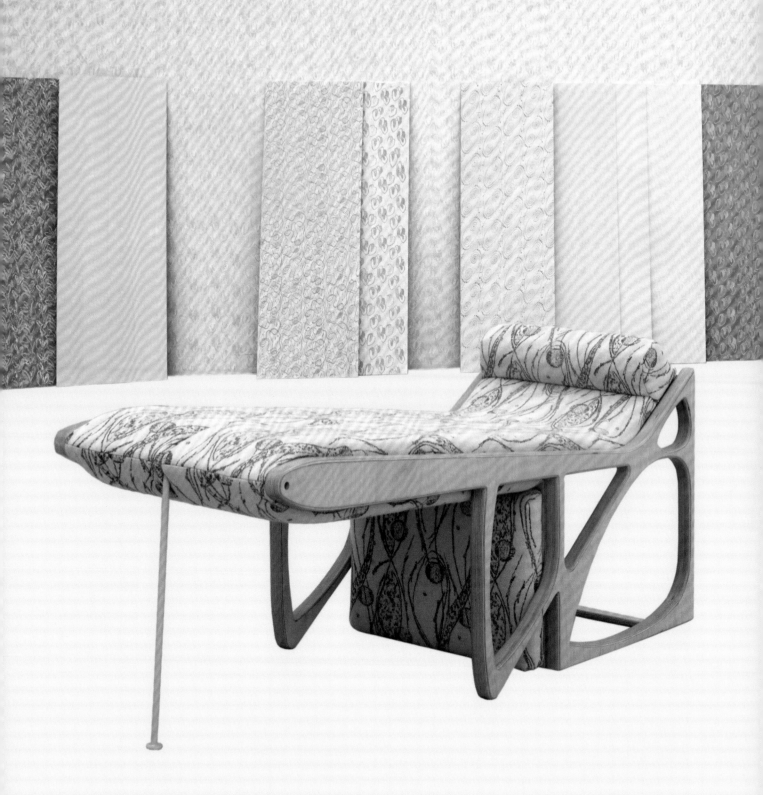

Thea Djordjadze

Thea Djordjadze explores the cracks in the surface of the everyday items around us, carefully juxtaposing materials, textures and objects to create assemblages imbued with personal and cultural memories. Her works might be collections of ethnographic souvenirs gleaned from an ancient but unspecified past. *Deaf and dumb universe* (2008) is a chair comprising two foam blocks smeared with plaster and given a tinge of blue paint. The 'seat' is supported on such spindly black metal legs that sitting on it would be out of the question. Hovering on the verge of collapse, it emanates a precarious tension. Pale, almost ghostly, the plaster nevertheless bears the trace of the artist's hand. It is as if Djordjadze has excavated and reconstructed it.

The blue table *Zurück zum Maßstab [Return to Scale]* (2009) is similarly latent with an underlying tension, while retaining a sense of the domestic. Something between a side table and a writing bureau, it is the kind of object we might use to retain keepsakes or display treasured photographs. On top there is a small plaster object, mysterious yet seemingly resonant.

The two tall black columns of *Untitled* (2006) have a totemic, otherworldly quality. Enigmatic and difficult to place, Djordjadze's haunting forms are like fragments unearthed from an unspecified time. They do not inhabit a subjective realm as such, rather they demonstrate the transformative potential of materials and the poetic possibilities embedded in the objects that surround us.

RP

Jimmie Durham

Jimmie Durham's *Imbissstammtisch* (1998) typifies an approach to making art where all materials — manufactured or naturally occurring — are treated as equal. A tree trunk jammed into an old Ford wheel hub and topped off with the kind of ubiquitous white marble you find in European restaurants, the work's title (literally 'snack-trunk-table') alludes to its usefulness as a piece of furniture as well as its special status (a *stammtisch* is a table where the proprietor sits with favoured guests).

Demonstrating the object-to-subject transformation that the artist's new configurations can bring about, *A Meteoric Fall to Heaven* (2000) features an elegant Viennese armchair desecrated by a heavy rock. The perfectly calculated missile has shattered its wooden frame and ripped through the upholstery, forcing it into a paradoxical new subject-hood as the victim of human violence. As the work's title suggests, this is not an act of God but a carefully orchestrated set-up, like most things in our mediated, earthly lives. Durham has said that sympathy with objects engenders imagination, both in the sense of creating pictures in the mind and allowing new ideas to emerge — consider, for example, *Stoning the Refrigerator* (1996) or the mangled bicycle in *Fin de la Semaine* (2000). The artist's vandalism not only liberates the object and its viewer from the norms of use, value and possession but also demonstrates how quickly these accepted standards can be assembled or dismantled.

Like the gutted chair, *Close It* (2007) — a man-sized black metal locker with electrical wire entrails and louvered grille face – evokes a human form. In this case, an insistent banging can be heard from inside, eliciting our confusion or surprised laughter. Theatrical and irreverent, these works might be described as critical jokes interrupting the drone of the everyday. While he may be anti-establishment — state, church or otherwise — Durham champions the importance of not taking oneself too seriously.

AB

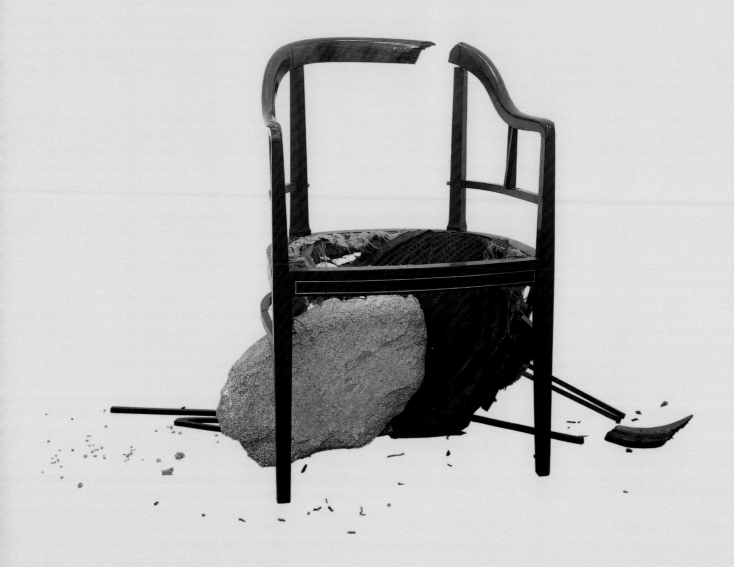

Close It
2007

69

Elmgreen & Dragset

Divided Time/
Powerless Structures,
Fig. 249
2002

Michael Elmgreen and Ingar Dragset employ a radical, at times theatrical, use of the site-specific to examine underlying social strictures. Taking public or institutional spaces as their raw materials, they investigate the indivisibility of architectural and social conventions. Through alterations to the fixtures, they suggest alternatives to the rigid behavioural standardisation that these structures not only reflect but also perpetuate.

An ongoing series of works entitled 'Powerless Structures', which began in 1997, explores attempts to undermine the authority implicit in these conventions by means of subtle alteration. Anxiety, frustration and desire are played out through furnishings, rupturing their generic finish, dimensions and usage.

In *Powerless Structures, Fig. 122* (2000), two ordinary white doors on adjacent walls of a corner are linked by a steel chain that joins their safety locks but hangs loosely between them like a back-pocket key chain. Though rendered dysfunctional and absurd in the gallery space the chain link suggests a newly intimate relationship between door and body whereby that body is not just an anonymous unit, but also a socially and sexually politicised individual. *Powerless Structures, Fig. 133*, 2002, shows a succession of doors fitting one inside the other like a Russian doll. Although a physically impossible conceit, it presents a strong visual image that challenges the one-size-fits-all principle. In *Powerless Structures, Fig. 136* (2002), meanwhile, a hairline crack runs from the top of a door to the bottom: a fundamental flaw in accepted social standards?

In *Boy Scout* (2008), a bunk bed familiar from youth hostels the world over is transformed into a vehicle of homoerotic desire simply by flipping the top bunk over to face the one beneath. *Marriage* (2010), meanwhile, in which two adjacent bathroom sinks are connected by an elaborate twisting waste pipe that never leads to an outlet, suggests the impossibility of adapting a heterosexual social convention like marriage to fit same-sex unions.

The standard unity of time is riven in *Time Out/Powerless Structures, Fig. 248* (2010) where one jagged half of a clock face lies on the floor while the other remains affixed to the wall, and *Divided Time/Powerless Structures, Fig. 249* (2002) where a gap between two halves of the clock separates the hands and makes telling the time an impossibility. Even in these sculptural one-liners, authority takes a sideswipe.

KB

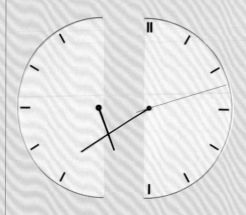

Boy Scout
2008

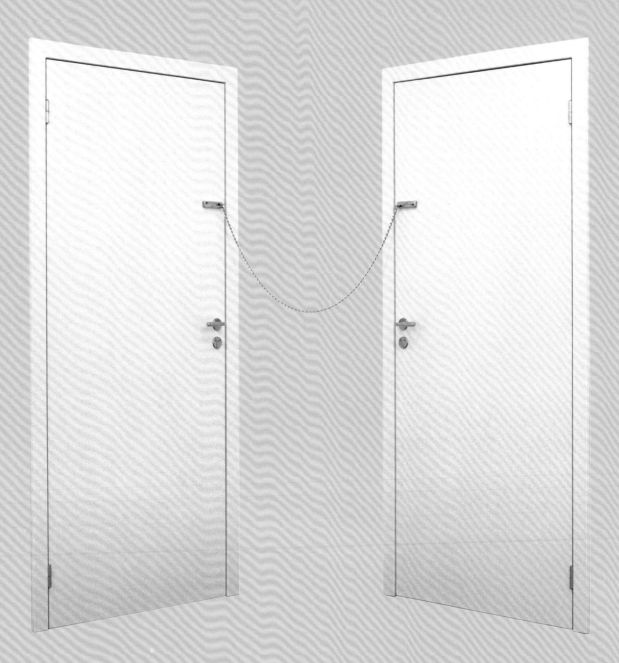

Powerless Structures,
Fig. 136
2002

Powerless Structures,
Fig. 133
2002

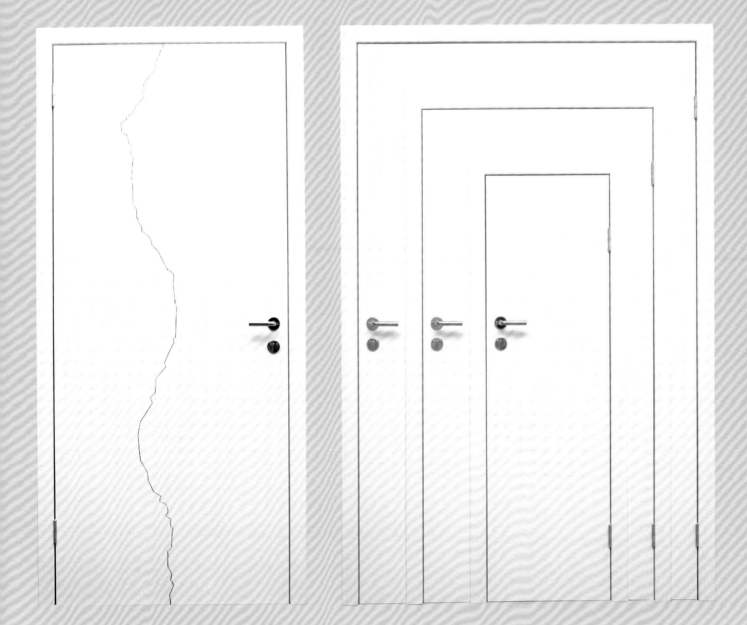

Spencer Finch

The light installations of Spencer Finch often reconstruct specific examples of external luminosity. Using everyday lighting equipment he attempts to recreate particular light conditions based on his observation of technical measurements, stimulating our senses in scenes that are resonant with poetry.

In *Night Sky (Over the Painted Desert, Arizona, January 11, 2004)* (2004) Finch turns our attention away from the obvious natural phenomenon of Arizona's Painted Desert, with its stratified layers of brightly coloured rock, to the twinkling heavens above. He presents a constellation of 401 dimmed light bulbs in an apparent attempt to replicate the night sky at a particular moment. Upon further examination we learn that the clusters are not in fact representations of the stars, but rather visualisations of molecular structures. Finch first painted a watercolour of the sky on the night in question and then employed simple scientific means to determine the atoms of the paint, which were then used as the basis of the stars.

Finch's work revolves around the problems and opportunities inherent in the act of representation. At an immediate level the ordinary house-hold lights elegantly recreate a night sky indoors, however it is not the night sky we thought. By representing the atoms from an image of the sky, Finch creates further distance from the original scene and in doing so imbues the process with greater significance. The accuracy that is achieved is not intended to introduce an empirical outcome, but rather serves to maintain the fleeting, subjective nature of observation.
RP

Urs Fischer

Urs Fischer's work demands a certain agility of reception, its point being not so much narrative sequence or associative understanding, but rather an elusive and circular process of transformation, in which idea confronts material and object confronts idea. The mundane objects he often employs operate like generic sculptural props through which complex ideas about physicality, perception and failure can be explored. Chairs, which come up repeatedly in Fischer's work, form a kind of basic unit, sometimes standing in for the human form. Though occasionally using found chairs, he more often remakes them with an exaggeratedly clunky hand-made aesthetic. They melt, are half-burned away, vibrate at such a speed so as to appear blurry, are daubed with muck, or fused with other objects in impossible visual non-sequiturs.

In *A thing called gearbox* (2004) an office chair, clumsily cast and painted, appears to be the anchor for a small copper cannon which is tied to its backrest and floats in the air like a balloon. The title, however, suggests that the chair's function is concerned with movement, or at least the transmission of energy from one object to another. Is it a metaphor for the activity of work, which can translate an idea into an action? The artwork cannot be logically unpacked: instead it seems to illustrate a fleeting, impossible thought. As Fischer put it: 'A chair is never a piece of furniture for me; it is part of a situation that establishes a real clash in space.'

The threshold as a perceptual interruption is another element that Fischer explores repeatedly. He has cut large holes in gallery walls to expose what lies behind in a surprisingly brutal act through which to establish the physical and visual continuity of space, and recast entrances as rough, primitive doorways that provoke an exaggerated sense of anticipation. *Untitled (Door)* (2006), is an oversized domestic doorway slotted into an institutional setting. It suggests a kind of dream space beyond, the possibility of something new and unexpected.
KB

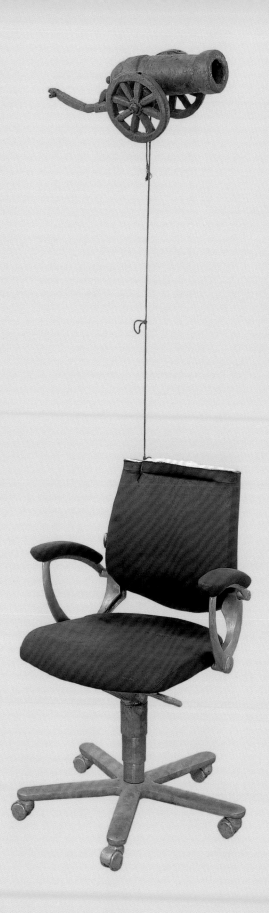

A thing called gearbox
2004

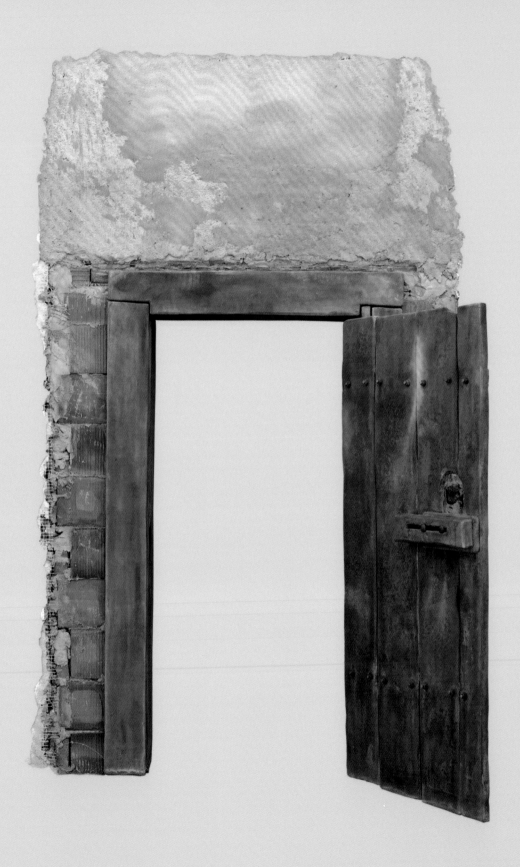

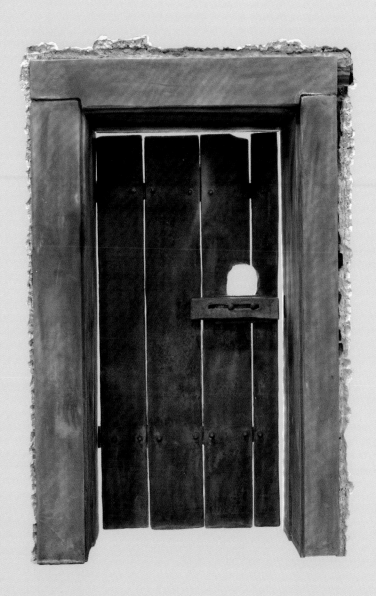

Gelitin

Works of art by Gelitin (Wolfgang Gantner, Florian Reither, Tobias Urban and Ali Janka) could be described as relics from a libidinal overture conducted against the constraints afforded by today's institutional white cube. The exaggerated and haphazard arrangements orchestrated by this Viennese quartet confront the viewer with an anarchic hedonism that might have its roots in the eighteenth century.

Gelitin invert and tease functionality. A plant pot doubles as an electrical socket (*Stromverteiler* [*Power Distribution*]) (2008) in an apparently innocent yet latently fiendish nod to multi-use ornamentation around the home. Meanwhile, in *Dustbin* (2008) a cheap melted red plastic basket is balanced on a structure of bones that might have been gleaned from a grave-digging expedition. Images of the Sedlec Ossuary mix with the remnants of the local rubbish tip in a wilfully confrontational assault on our sense of decorum.

Gelitin do not take quotations from design history, rather they forcibly weld discarded furniture into new deviant forms. Made from sections of found furniture, many of their pieces have the appearance of hacked off limbs forcibly conjoined with other append-ages to create *objets d'art* at once monstrous, tender and beguiling. This splicing together of elements is particularly evident in the chandelier *Today tomorrow maybee*, (2010), whose gangly arms comprise multiple chair backs and legs to support their bulbs. In *Untitled* (2004), a grotesque fluffy creature lifts aloft a bucket lamp via its single limb, while a couch *Untitled* (2009) presents the sitter with a row of upturned teddy bears, shackled amidst the structure, their backsides braced for impact. Gelitin's work is infused with unconscious desire in a way that is playful and implicitly erotic.
RP

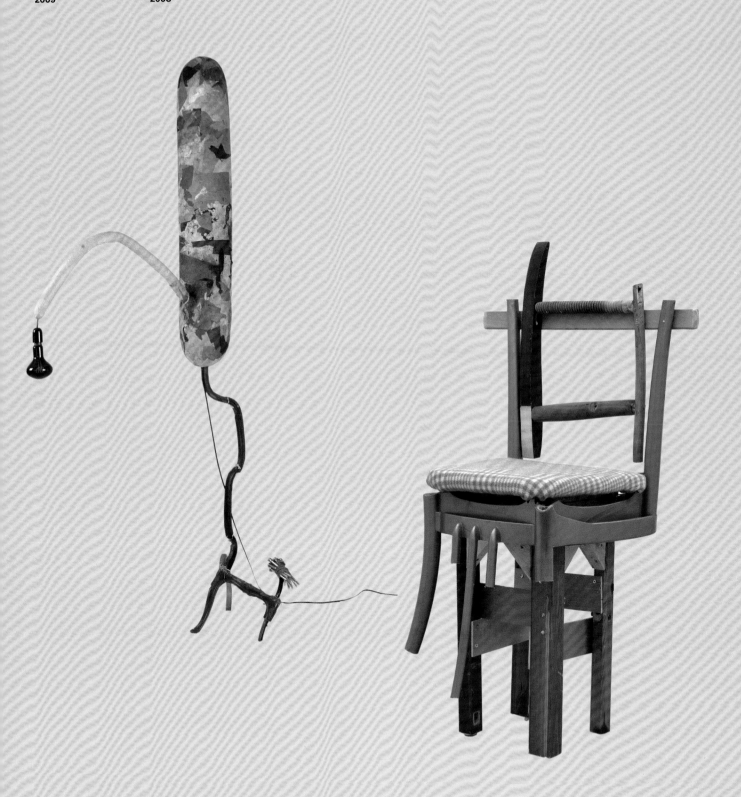

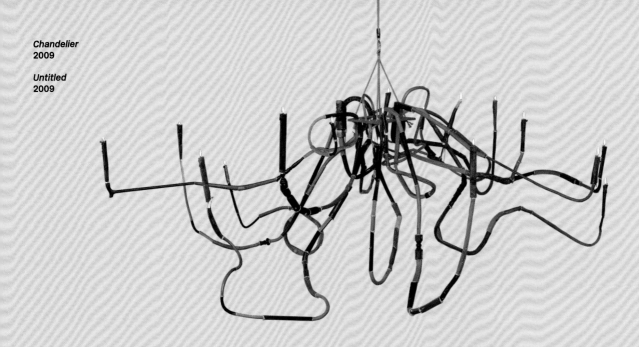

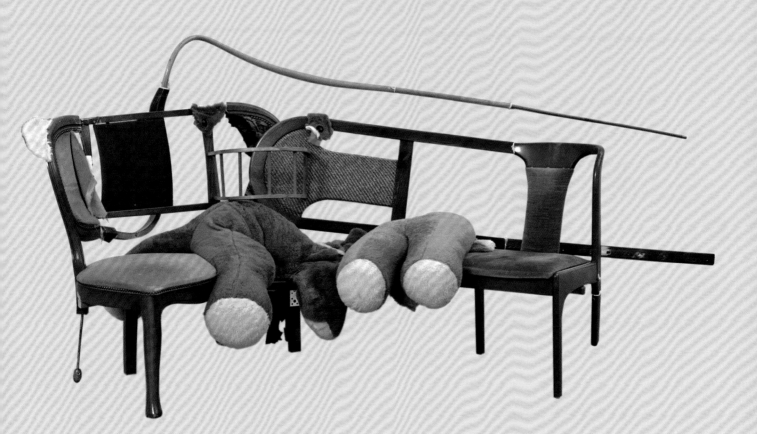

83

Fabrice Gygi

A printmaker, radical performance artist, self-tattooist and sculptor, Fabrice Gygi was born into a highly sanitised culture of order, discipline and protection, and has spent most of his life rebelling against authoritarian society. 'For me, art is like resisting,' he explains. 'It helps me to survive in a society despite the fact that I completely disagree with it.' He has installed crowd-control devices and gigantic airbags in museums, made ceiling lights from bombs, transformed a submarine mine into a chandelier and constructed a 12-metre-high watchtower to keep guard over the São Paulo Biennial. 'I've occasionally been reproached for using the same authoritarian forms as the society I denounce,' Gygi admits, 'but that's only a diversion, a way of saying: "You've got the atom bomb, me too".' He views his impeccably fabricated sculptures and installations as 're-transcriptions' of things he has seen around the world, and says that he tries to appropriate the object by making it anew from memory.

Gygi's early sculptures included ambiguous tent-like structures which suggest military bivouacs, refugee camps, temporary hides and provisional shelters, evoking ideas of protection and menace at the same time. Belonging to this group of works but markedly different in mood, *Table-Tente* (1993) is a surprisingly tender creation. A scruffy table and paint-spattered stool act as supports for the tent's pristine skirts. Somewhere between an igloo, a home-made bomb shelter and a hiding place for a small child, it is domestic and intimate but not entirely innocent; combining the makeshift and the highly-finished, it presents playfulness balanced by seriousness.
HL

Table-Tente
1993

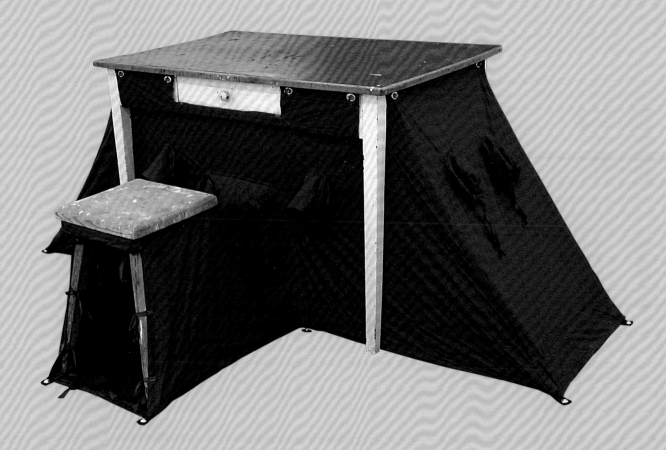

Heiri Häfliger

Heiri Häfliger's *The early bird catches the worm* (2007) is an improvised lamp that looks like it was made using materials casting about in the artist's studio. In it, an ordinary household light bulb sits atop an ordinary, blue household bucket, the kind used to wring out mops or to catch drips from a leaky ceiling. For this unassuming contraption, Häfliger has designed a comparatively elaborate lampshade made from his most commonly used material — papier mâché. The lamp-shade starts out as a round white tube, resting at an angle to allow the bulb's light to escape from underneath it. But the tube soon expands into several spindly bands that radiate from the lamp like undulating octopus legs, casting stripes of long, narrow shadow on the walls around it. The entire sculpture sits on a round, wheeled wooden pedestal that allows the lamp to become mobile.

This exuberant variant on a lamp, made from humble, found and craft-related materials, is typical of the artist's sculptures, which often climb the walls or spill out across the room. The installation *Cut* (2007), for example, is made from 14 swatches of carpet cut into shapes and pasted onto a white wall to simulate black holes, while the discarded carpet leftovers lie twisted on the floor in a tangled heap. Similarly, *Eintagsfliege* [*Mayflies*] (2009) is a swarm of papier-mâche pieces bent to look like flies that appear to crawl up and along the walls. In another lamp by Häfliger, *WAMP/LAMP* (2005), a light bulb hangs overhead and a puddle of pink papier-mâché strands pool beneath it, held aloft by common cable ties. In these works, Häfliger employs modest materials to make unexpected shapes that act as lines drawn by the artist's hand, expanding to fill and decorate the room.

CL

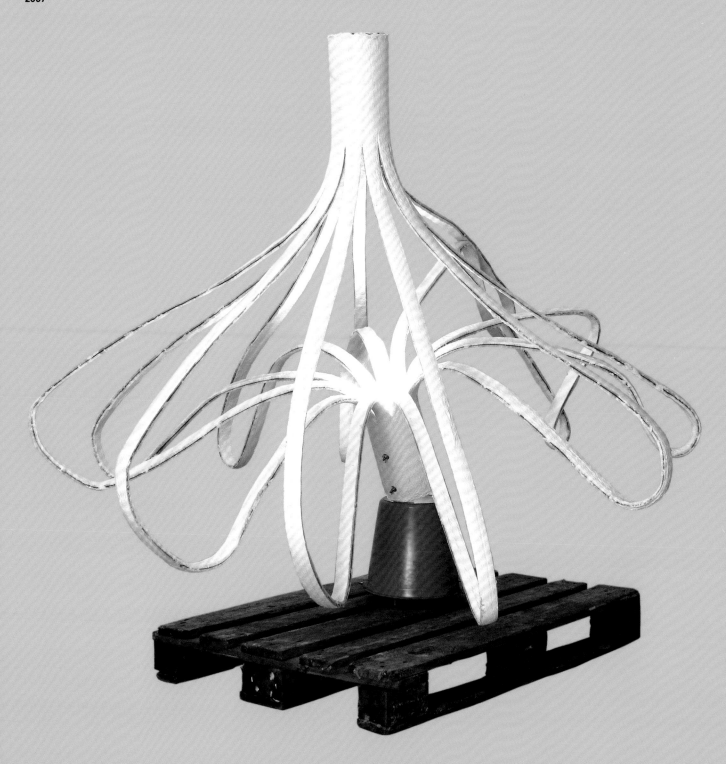

Mona Hatoum

With *Interior Landscape* (2008), Mona Hatoum presents an apparently stark and foreboding cell. Rather than being a place of refuge, the space is revealed as a metaphor for the dreams and aspirations of a displaced Palestinian individual, juxtaposed with the harsh realities of everyday life.

Upon entering the room we discover several representations of the map of Palestine, highlighting its precarious border. A pillow with the outline of the country from the pre-1948 map, sewn from the artist's hair, lies on a bed with a barbed-wire base, while on the wall a pink coat hanger has been pulled to form a similar outline. Alongside it hangs a bag, fashioned by slicing into another historic map of the country, this time a printed version with Arabic writing. On a side table by the bed a food tray bears an 'accidental' drawing formed by grease marks, which the artist has outlined. For Hatoum this is reminiscent 'of the present map of the territories divided into a multitude of parts with no territorial integrity amongst them'. *Interior Landscape* evokes both prison and piety. The space itself is devoid of life, bearing only the recent trace of a former presence — the residue of trauma.

Two further works — *Static II and Baluchi (blue and orange)* (both 2008) — are placed outside the room. *Static II* is an elegantly worked metal chair with a spider's web of red glass beads stretched across it, suggesting the gathering of cobwebs over time. For the artist, this is a reference to 'static lives' of people who have nothing better to do but sit around all day on such an ornate seat. In *Baluchi*, a traditional oriental carpet appears to be in an apparent state of disintegration. Large sections of the pile have been moth-eaten or worn away in what at first glance look like random patches but which on closer inspection form a recessed impression of a world map — one in which man-made frontiers dissolve.

RP

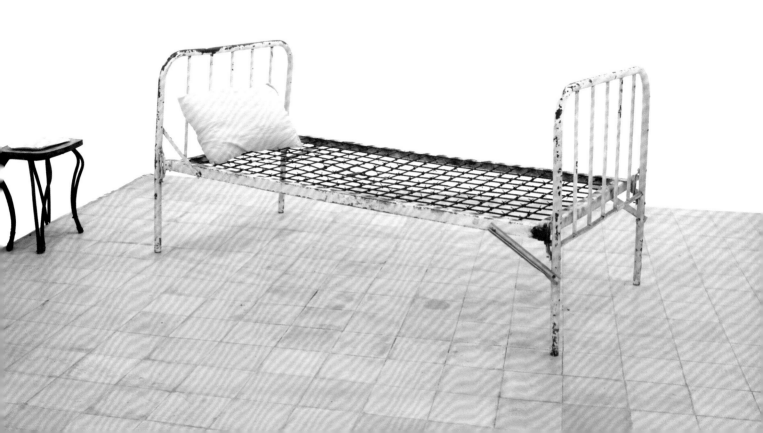

*Baluchi (blue
and orange)*
2008

Diango Hernández

After studying Industrial Design in Havana in the early 1990s, Diango Hernández became one of the founders of Ordo Amoris Cabinet, a Cuban artists' and designers' collective. This group's particular focus was the 'provisional aesthetic' of making do and getting by adopted by ordinary people during Cuba's 'Special Period', the years of acute economic crisis caused by the collapse of the Soviet Union. A decade later, Hernández left Cuba, which trade embargoes and extensive censorship had isolated from the rest of the world, and moved to Europe in order to 'know more, learn and do more'. Since then, all of Hernández's work — paintings, drawings, collages, installations and sculpture — has constituted an investigation into the 'realities hidden beyond the realities' of revolutionary Cuba and its failed Utopia. 'I cannot detach myself from my past,' he insists. 'On the contrary, the past has become like a wardrobe from which I can take out memories and experiences to re-analyse or re-elaborate.'

No tea, no sofa, no me (2009) fuses reflection, longing and reverie, and meditates on frustrated desires for intellectual life in Hernández's homeland. The installation consists of three principal elements: the back of a dismantled sofa frame and its dislocated arm (both of which are supported by speaker cabinets), and a skeletal lampshade through which is threaded a pair of workman's trousers. The objects displayed in this comfortless roomscape point to specific conditions in Cuba: the elegant teacup balanced precariously on the back of the sofa is empty (tea has been unobtainable for domestic use since the 1960s); the light bulb cannot be used (incandescent lighting has been banned since 2005); the plate commemorating President and Mrs John F. Kennedy dates from the beginning of the USA's boycott; and the box of matches comes from the period of the Soviet Union's support for Cuba. Besides these presences there are also significant absences, notably in the lack of anything to read (in Castro's Cuba there were no books except those sanctioned by the regime). Against this is the fact that the speakers — which in other works by Hernández give voice to ranting speeches — are silent.

Light is a recurring theme in Hernández's work and often makes reference to the power cuts that are an everyday occurrence in Cuba. In *Leg me, chair me, love me* (2010), a new commission for the Hayward, a wounded, three-legged chair waits to be reunited with its missing limb, which circles alongside it on a slowly revolving floor. Every so often, when the fourth leg momentarily resumes its proper place and the piece of furniture becomes whole again, the light hanging nearby comes on, briefly illuminating the miraculously intact chair. Then the leg moves on, the light goes off, and the chair again becomes an amputee.

HL

No tea, no sofa,
no me (detail)
2009

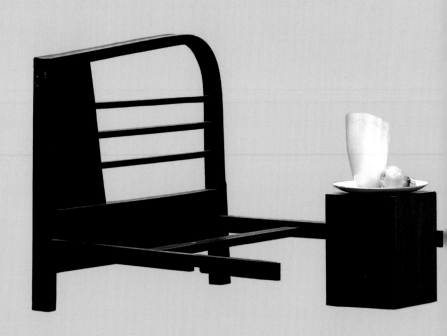

No tea, no sofa, no me
2009

Yuichi Higashionna

Yuichi Higashionna's paintings, installations and sculptures are often drawn from, or incorporate, ordinary everyday things which are known in Japanese as *fanshii*, a term derived from the English word 'fancy'. *Fanshii* objects are typically kitsch and tacky, and are odd in the sense that they belong neither to Western nor to Japanese culture. Higashionna admits that he has never liked *fanshii* things, which became a feature of Japanese homes in the post-war years. Nevertheless, he finds himself irresistibly drawn to them. He recognises that what he finds so disquieting about these objects is their uncanniness, in the Freudian sense of something that is at once familiar and foreign. This perception of the uncanny is the impetus for much of his work and under its influence Higashionna transmutes *fanshii* goods such as cheap lace curtains, plastic flowers and fussy floral prints into works that combine humour and eroticism with optical overload.

In a series of spectacular chandelier sculptures, Higashionna fixes on another Japanese obsession: ultra-bright fluorescent light. Believing that there is 'probably no country as fond of excessively white fluorescent light as Japan', he points out that circular fluorescent lamps, as featured in *Untitled (Chandelier VII)* (2005/2008), were widely used in Japanese homes after the war. In contradiction of such traditional aesthetic values as darkness, reticence and quietude, they symbolise something peculiarly redolent of modern Japan. Bristling with plastic ties and festooned with swags of wires and cables, *Untitled (Chandelier VII)* dazzles and hums. Higashionna sees this work and the series to which it belongs as a 'tribute, both a homage and a satire' to this Japanese 'fluorescent culture', which fascinates him and at the same time makes him distinctly uneasy.
HL

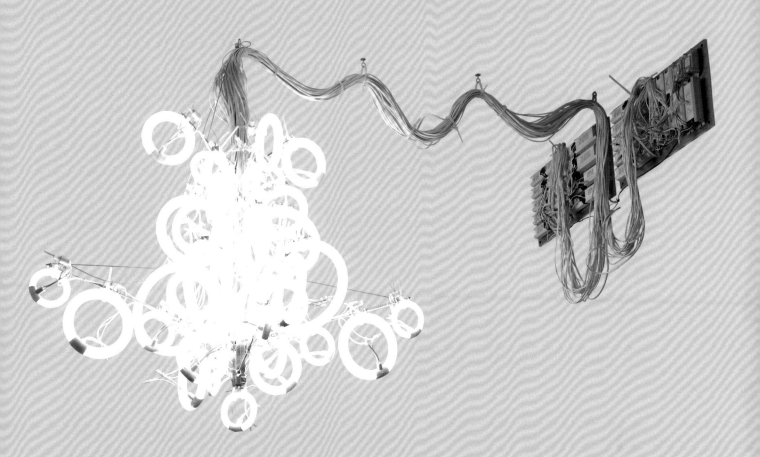

Jim Lambie

The everyday nature of the materials the Scottish artist Jim Lambie uses is striking. *ZOBOP* (2002) is made from sticky vinyl tape, *Get Yr Freak On* (2008) is a door covered in numerous knobs, latches and handles, while *Bed Head* (2002) is composed of an old single mattress and several thousand buttons. What Lambie does with these materials, however, is often captivatingly complex in form, with lush textures and colours emanating an exotic and sensory allure.

ZOBOP is one of Lambie's ongoing series of floor pieces created by sticking vinyl tape to the gallery floor. Construction begins with a single stretch of coloured tape encircling the room's perimeter. Inside this another round of tape is added and then another, until a vinyl rainbow extends to the centre of the room, catching the floor's irregularities in offbeat rhythms of line and hue. Currently installed on the ramp of the Hayward Gallery, the work is different each time it is shown. *ZOBOP* is also an exercise in presence and absence. Being the largest work a room can accommodate, its throbbing colours inevitably dominate any location. At the same time, since it doubles as a floor, Lambie effectively offers us empty space.

As with much of Lambie's work, the cheap sparkle of *Bed Head*'s many buttons resonates with pop music's fleeting, glittery appeal and its promise of special tribal identity. Yet while the painstakingly sewn-on buttons point to the customised outfits of youth and music culture, the lonely single bed suggests unfulfilled yearning. Its grubby seams make a melancholy counterpoint to the gorgeous encrustations of haberdashery. Evoking the conflicts of adolescence, the work suggests a division between what is going on inside and what one hopes to present to the world. There is a similar sense of overcompensation to *Get Yr Freak On*, overdressed as this door is in knobs and latches: phallic protuberances that mirror its title's sexual come-on and suggestion of freakishness.

ss

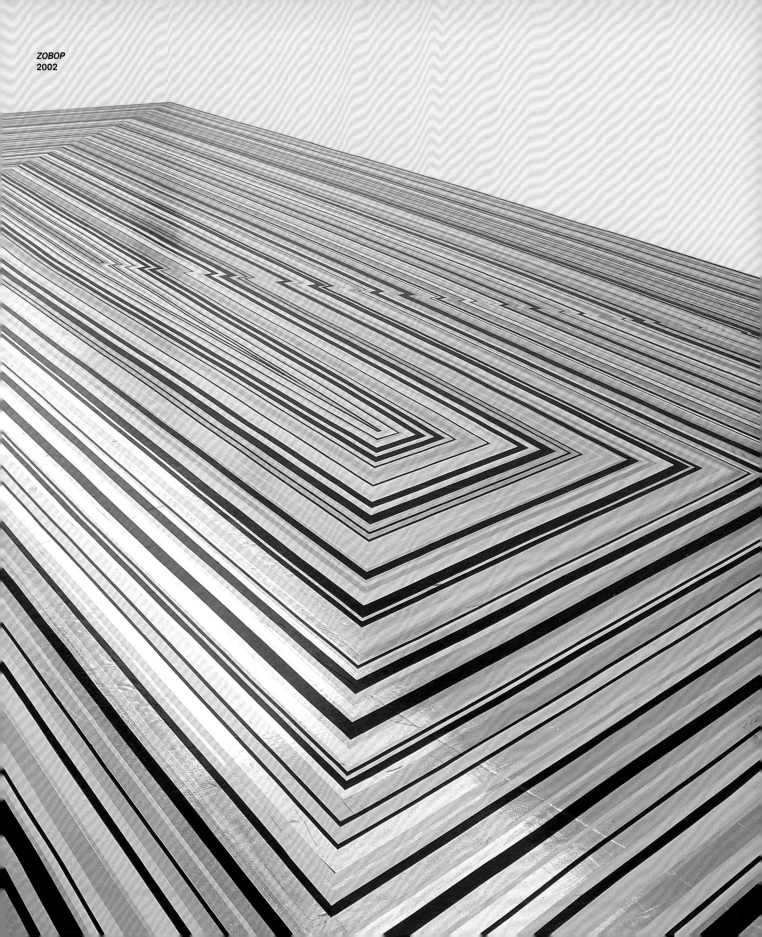

ZOBOP
2002

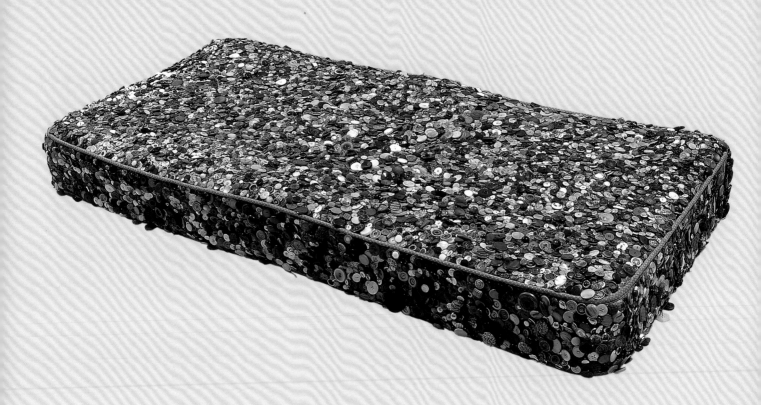

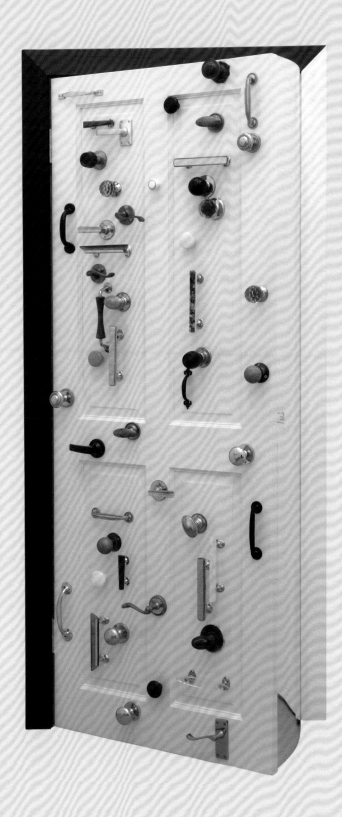

Sarah Lucas

Sarah Lucas' sculptural tableaux adopt a junk-shop aesthetic to describe a grimy, downbeat existence. Like the sculptural equivalents of a kitchen-sink drama, they favour coarse visual language, combining shabby armchairs and hideously stained mattresses with suggestive arrangements of fruit and vegetables in deadpan assessments of the human condition (*Au Naturel*, 1994). For Lucas, the vernacular is the only means of expression. She limited her criteria early on: 'It has to be readily available/ cheap (or I can't find it/afford it), it has to interest me and it has to interest others.' Following these guidelines, Lucas gained notoriety in the early 1990s with her wholesale appropriations of sensational tabloid headlines and junk furniture assemblages that approximate the human body to suggest not only a decrepit domesticity, but also our own tawdry physicality.

Where the chair is not a stand-in for the human figure itself, it is a prop, whether in Lucas's many self-portrait photographs, where she slumps snarling in an armchair, in work boots and jeans, legs spread. Or in a series of works that began in 1997, where long-limbed headless figures made from stuffed nylon tights, generically titled 'Bunny', sprawl drunkenly on chairs. Domestic furnishing is the inseparable scenery for these reductive visions of humanity.

In *Fuck Destiny* (2000), a battered old sofa bed assumes anthropomorphic attributes, with a pair of light bulbs for breasts on its reclining frame and a long phallic fluorescent light that penetrates a tear in its red vinyl upholstery. The sexual innuendo that runs throughout her work is impossible to miss here, but the offhand way Lucas combines these elements, propped casually on a packing case, is an exercise in sculptural confidence and her ability to instill the cheap and readily available with metaphysical resonance. Cultural cliché of a particularly British sort may be her raw material, but her sculptures, even when they feature grubby toilets or stinking food standing in for genitalia, suggest melancholy sympathy rather than ridicule for life's sorry protagonists.

KB

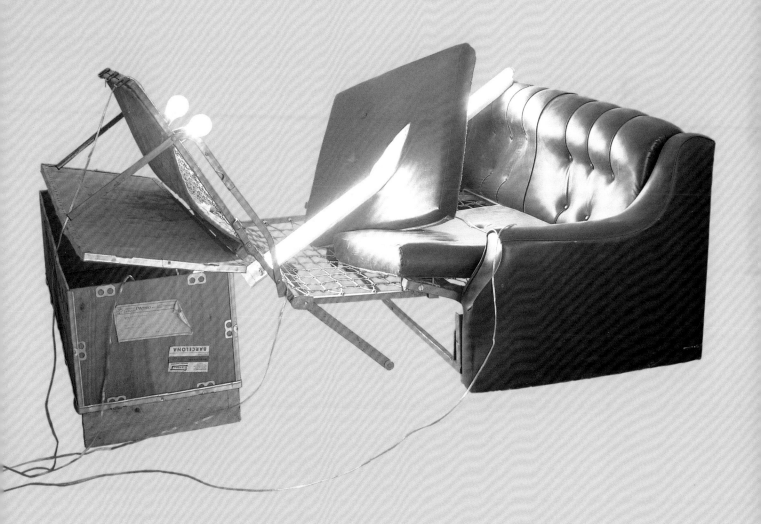

Ernesto Neto

Consisting of a table, a matching group of eight stools and a divider screen, Ernesto Neto's *Life is Relationship* (2007/2010) creates an intimate social space within the bustling lobby of the Hayward Gallery. While the screen serves to create a more sheltered setting for people gathered around the table, it also functions as a backdrop to the large front window, exposing the whole scene as a tableau to passers-by outside. The furniture elements are cut from large sheets of wood and assembled without screws or hinges, a method characteristic of the artist's desire for honesty in materials and construction methods, but it is also a play on the idea of ubiquitous flat-pack furniture. In Neto's work, the negative cut-out sheets often become sculptures in their own right and are sometimes joined together in series to create freestanding screens. This furniture is also linked to a series of sculptures that he has been developing in recent years. Based on a child's toy consisting of interlocking cogs and struts, Neto's wooden and metal sculptures are made in a variety of sizes ranging from miniature to monumental. His furniture in turn is between adult and child-sized, ambiguously accommodating both and excluding neither.

Although Neto's works, including those using his signature nylon material, have grown in size over the past 20 years into large-scale installations, he has designed them to be inhabited, filling them with padded floors, soft cushions and other 'furnishings'. *Life is Relationship* was originally part of the larger installation *From Sebastian to Olivia* (2007) at Galerie Max Hetzler, Berlin, in which the furniture suggested a potential meeting place for visitors. These works all stem from his over-arching interest in bodily relations and human relationships. Neto creates experiential environments for relaxation and contemplation, but also of intrigue and amusement. As the artist has said, 'My whole idea of the possibility for art to change the mood of people and through that, the way we live, has been a strong utopian factor in my sculptures.' By both modifying and creating social spaces, Neto ensures the connectedness between art and life.

CL

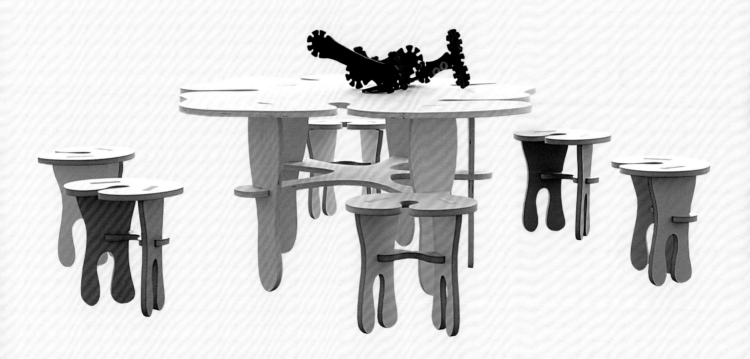

Manfred Pernice

Through the window of the former butcher's shop where Manfred Pernice's 2008 exhibition was originally installed, one could see a constellation of perfunctorily abandoned objects, as if the remnants of a recent house party had been left to decompose. *Usinger* (2008), a defunct kiosk pasted with pictures and photocopies, was covered in a patchwork of tiles. Nearby, *Kaskel-treff* (2008) comprised three tiled cubic stools flanked a low-slung plywood bar, barely higher than the gallery's heating unit. The countertop offered bowls of stale tortilla chips, cookies and used books as well as several practical hooks on which to hang coffee mugs. Like many of Pernice's installations this was a *bricolage* of DIY building materials, accompanied by clippings, sketches and photos that appeared to be culled from a vast collection of discarded post. The atmosphere recreated a semi-public communal space — the title *Kaskel-treff* referred to a nearby hangout in Kaskelstrasse, where neighbours get together and exchange books over coffee and cake.

If this seems like an unlikely cross between a public monument and a temporary social club, the heroes honoured in *Kaskel-treff* and *Usinger* are equally curious. Pernice's installations memorialise two successful entrepreneurs who hailed from the artist's own hometown of Wehen, Germany: Fred Usinger, a nineteenth-century butcher who went on to open a thriving sausage business in Milwaukee based on his secret recipe, and Wolf Gehrlach, creator of the Mainzelmännchen — six Smurf-like mascots for the German television channel ZDF.

Mixing scraps of personal and collective histories, while leaving their significance ambiguous, Pernice suggests the arbitrariness of historical monuments. His slapdash use of building materials recalls the contradictory nature of Berlin, its boulevards of grandiose statues contrasting with its ubiquitous construction sites. Pernice's constructions represent modest attempts to improve the world, not through Mies van der Rohe's brand of Modernism but with a more humble B&Q-inspired version, based on small and necessary conveniences.
CL

Raqs Media Collective

Formed in 1992 and based in Delhi, Raqs Media Collective's practice encompasses writing, photography, film, video, new media, theory and criticism. They explain that their name, Raqs, is 'a word in Persian, Arabic and Urdu and means the state that "whirling dervishes" enter into when they whirl […] At the same time, Raqs could be an acronym, standing for "rarely asked questions"'. Their cross-disciplinary work takes the form of installations, image-text collages, online and offline media projects, lectures, performances and encounters, but their overarching interest is in dialogue and discourse, and their special concern is for the dispossessed. In 2000, Raqs co-founded Sarai Media Lab at the Centre for the Study of Developing Societies, and since then they have established the Cybermohalla Locality Labs for disadvantaged young people. *Mohalla* means neighbourhood, and this initiative consists of a network of media laboratories located in poor areas of Delhi.

Much of Raqs' work is to do with notions of contemporaneity; one of their concerns has always been, they say, 'to look at different kinds of connections and connectivity in time and space'. And they add: 'we are constantly looking at the history of the moment in which we are in now.' *A Day in the Life of ___* (2009) presents us with the type of plain, round-faced wall clock familiar from schools, waiting rooms, work places, offices and public spaces, where we learnt first to tell the time and then to watch it with anticipation, excitement, dread, hope, agitation, indifference and all the inflections of our internal lives. Here, the dial measures and co-ordinates not time but states of being. Hours and minutes are replaced by feelings and emotions, which tick by relentlessly in different combinations and intensities until at midnight (or noon) there is a moment of pure epiphany.

As Raqs write, in the here and now, wherever we may be in the world, 'circadian rhythms (times to rise and times to sleep, times for work and leisure, times for sunlight and times for stars) become muddled as millions of faces find themselves lit by a timeless fluorescence that trades night for day. Sleep is besieged by wakefulness, hunger fed by stimulation, and moments of dreaming and alertness are eroded with the knowledge of intimate terrors and distant wars.'

HL

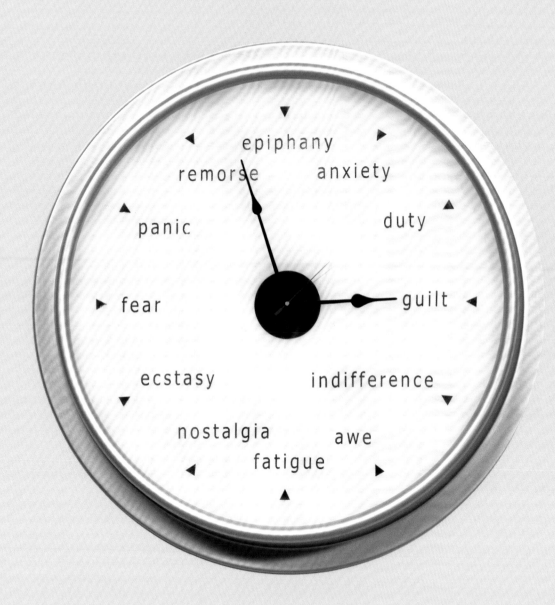

Ugo Rondinone

In Ugo Rondinone's installations, moods are constructed through a range of different media and interior spaces are laden with suggestion but drained of specific meaning. Objects seem to carry heightened significance, as if they appear in a dream, so that while they may appear familiar, they are unmoored from their usual situation and become psychologically charged. *still. life. (johns fireplace)*, 2008, for example, looks like an archetypal nineteenth-century living-room fireplace, but it is in fact cast in bronze, filled with lead, painted to look like the original (complete with *trompe-l'oeil* smoke stains) and set in a white gallery wall. It is an over-determined replica of reality, an artificial version weighed down through its physical material rather than any functional or gravitational grounding.

Doors, which appear frequently in Rondinone's work, have an equally atmospheric function as symbols of an in-between state. In his solo exhibition at the Whitechapel Gallery, London (2006), a labyrinth of black lacquered doorframes, *All those doors* (2003), created a disconcerting scenario in which thresholds are continually crossed but no goal is ever reached.

In contrast to this airy installation is an ongoing series of heavy, rustic, wooden doors, begun by the artist in 2006. Each of the series, which currently numbers 14 and will ultimately amount to 26, represents one letter of the alphabet and is titled accordingly: *lax low lullaby* (2010), for instance, or *vague vast void* (2008). Bolted and padlocked with huge keyholes, chains, heavy hinges and rough boards painted in shades of grey, they seem laden with mythology, mystery and dark significance. Why are the doors locked? What lies beyond them? Arousing fear as much as curiosity, they are as full of psychological portent as the fictional locked doorways of Bluebeard, Jane Eyre and Edgar Allan Poe, suggesting a terrifying or deranged unknown lying on the other side. But functionless and out of place here on the gallery wall, they also beg the question: are we locked out or locked in? Are we already living the unknown horror we fear? Given the obvious artificiality and self-conscious theatricality of the doors, however, the uncertainties they provoke seem as rehearsed as the works themselves.

KB

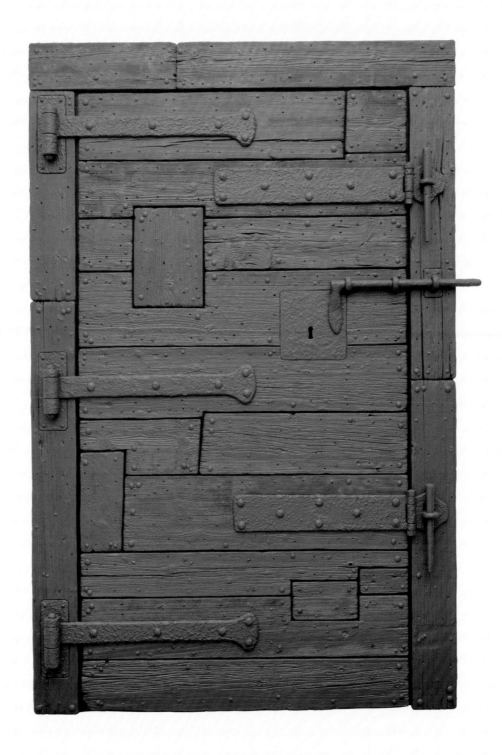

Doris Salcedo

The well-worn cupboards, dressers, chairs and tables that Doris Salcedo reconfigures in her sculptures and installations, suggest a sense of history, of life lived. Yet they also conjure feelings of loss. When people die or are forced to flee their homes, their furniture gets left behind. *Untitled* (2008), comprises two similar arrangements of blocky non-descript objects that might be dressers, which have been laid, coffin-like, on their sides. In a gesture suggesting suffocation and voices stifled, Salcedo has filled the negative spaces of these wooden boxes with concrete, a harsh material more usually associated with an official, even authoritarian, public sphere. Although the battered wood implies an intimate homely interior, her concrete-faced sculptures have been rendered anonymous, their original purpose no longer discernable. A table protrudes from each of the now useless, cumbersome cabinets, its legs shackled by dead weight. The split between the twin configurations of furniture evokes one of Salcedo's crucial concerns. It implies the rupture caused by violence, be that the resulting trauma that renders memory as unfathomable as a block of stone or by displacement, further fragmenting our sense of selfhood and its intrinsic connection with the homestead.

Violence has defined daily life for many people in Salcedo's native Colombia, but she resists mapping specific events onto her work, signalling instead to global issues. In recent years she has turned her attentions to architectures of power. Addressing the wider political implications of division in terms of the weak (war-torn impoverished countries) and the strong (the moneyed West whose cultural organisations proclaim its might), these works have included her fissure in the concrete floor of Tate Modern's Turbine Hall, *Shibboleth* (2007). With *Untitled* (2008), however, Salcedo has returned to the reconfigured furniture she produced in the early 1990s, Invoking the power dynamic between the First and developing worlds, here her domestic, beaten-up objects ingrained with personal details, make a moving contrast with the clinical white walls of the art institution.

SS

Jin Shi

Jin Shi's installations and photographs capture slices of everyday life as experienced by ordinary people in China, many of whom struggle to make a living at the lowest level of society. In a series of works called *Small Business* (2009), he converts tricycles into mobile enterprises, in common with many street vendors. One trike becomes a customised karaoke booth, another trundles a couple of small-scale billiard tables behind it, a third is transformed into an exotic foot spa with a pagoda-like roof and shimmering bead curtains, and a fourth is conjured into a fairground fishing game complete with miniature bathtub, toy fish and fishing rods. In creating these ingenious contraptions, Jin Shi purposely turns away from straight documentation; while wanting to make something reasonable enough to be believed, he also aims to 'keep a distance from reality'.

In *½ Life* (2008), this distance becomes a matter of scale: the work reproduces the typical living quarters of a migrant worker but reduces the cramped room and all its contents to half life-size. The viewer looks down on this miniature world, just as the rest of the population look down on the 150—200 million *mingong*, the Chinese migrants who are crucial to the nation's economic development but are forced to live 'half lives' on the margins of society. *½ Life* is a portrait of one such worker as revealed through his meagre possessions. Believing that 'objects can be far more persuasive than an image of man, because man can pretend, but objects can't', Jin Shi faithfully recreates half-size versions of many items himself, and uses other strategies, including collage, appropriation and assemblage, for things that cannot be made entirely by hand. In this way he finds himself replicating the activities of the migrant workers themselves, who depend on their own ingenuity in making do and getting by. 'Despite the limitations, they have imagination and creativity, which is very precious', Jin Shi observes, pointing out that 'this is also where the life of art is.'

HL

½ *Life*
2008

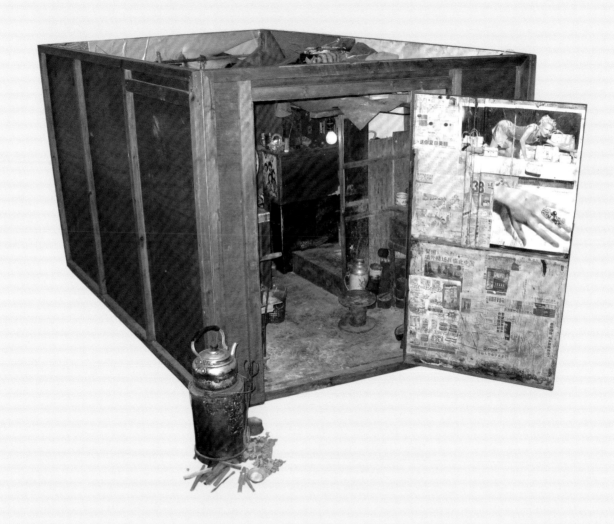

Roman Signer

An object in motion will stay in motion, unless an outside force acts upon it. Thus, a stool catapulted from a window will continue along its parabolic trajectory until it makes contact with the ground. The sculptures of the Swiss artist Roman Signer often take the form of seemingly quixotic scientific investigations performed upon the objects that surround us in everyday life. Since the early 1970s, he has tested Newton's first law of motion on office chairs, stacks of paper, minibuses, kayaks and bicycles, and set off explosions and triggered minor eruptions, capturing the results on film.

In Signer's actions, which he prefers to call 'time-sculptures' or 'occurrences', ordinary items, and sometimes the artist himself, become suddenly activated by unexpected natural and physical forces. In *Bürostuhl* [*Office Chair*] (2006) for example, he records himself sitting in the chair, holding two lighted fireworks as the chair spins wildly and the fireworks burn. Often, the artist sets two things on a path to collide with one another — perhaps a running lawnmower set loose among chairs — as an elementary way of constantly rearranging the room's furniture.

Recent works by Signer are often propelled into motion by atmospheric forces such as wind or water. *Schwebender Tisch* [*Floating Table*] (2005), for instance, does what the title implies, but rather than floating by an act of magic or levitation, the table is held aloft by a violent blast of air coming from a hole in the floor. The most elementary piece of furniture is activated and animated by the artist, but it is also rendered useless; this wobbly table is no place to set your fine china. *Floating Table* is unique among Signer's works because it does not undergo a dramatic change of state; rather it continuously defies gravity. Nevertheless, like all of his physical experiments, the results never fail to surprise us.

CL

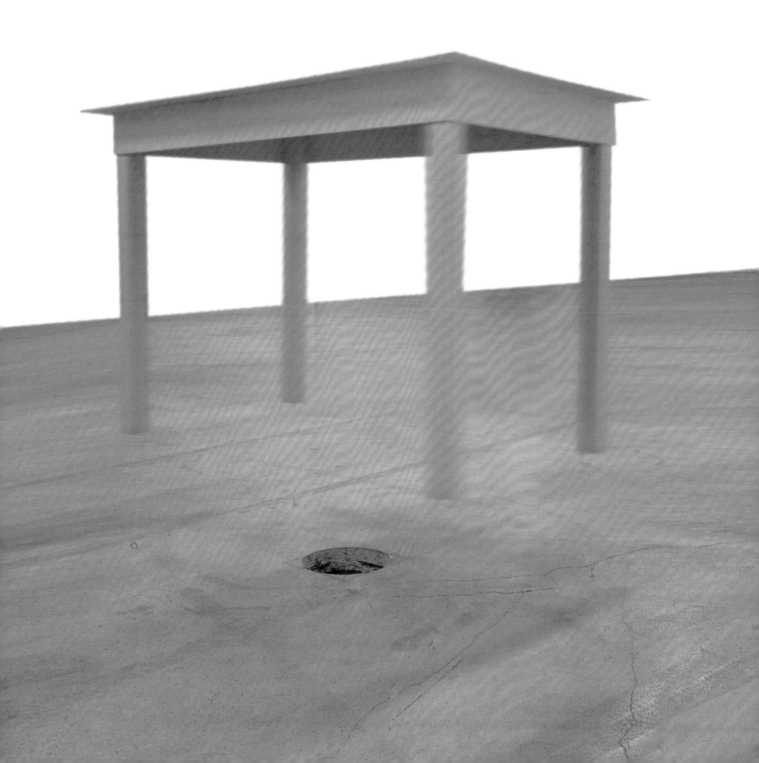

Pascale Marthine Tayou

Pascale Marthine Tayou is nomadic, both in his life and his art. Born in Cameroon and based in Belgium, his sculptures, films, photography and installations have often served as testaments to his itinerant existence. They frequently feature an accumulation of the detritus picked up on his journeys; rail tickets, fast-food wrappers, plastic bags, receipts and the packaging from toiletries. But this is not a recycling project. Rather Tayou's layers of debris speak of his diffuse identity and suggest the accretions of memory.

Crazy-Nomad-02/Globe-trotters (2007) is a trio of anthropomorphic assemblages of junk. Cheap paper lampshades, plastic packaging and light bulbs have been stacked to create overloaded squat forms that stand, stork-like, on the wheeled bases of mobile postcard display units. Familiar materials become weird and dishevelled totems of travel. They continue Tayou's interest in agglomerations that align local custom and global forces, developed through large-scale scatter works and installations. An earlier meditation on the 'Crazy Nomad' theme, his 1999 exhibition of that title at New York's Lombard-Freid Projects, featured fabric strips culled from the bins of local businesses strewn over the floor along with wine bottles and plastic cups left over from the private view. Streamers of rose-petal-like paper hearts, ticket stubs, grocery packaging and other tokens of transit, decked the walls, alongside drawings of totemic figures, whose ritualistic tenor was echoed by a sculpture made of string, wire, elastic bands and pins.

Boundaries are constantly shifting in Tayou's work. In the large-scale installation *Human Being @ Work* (2007) for instance, the interconnectedness of lives seemingly divided by culture and geography is emphasised. Wooden huts reminiscent of an African shantytown become a global village, with films portraying daily happenings in locations as far-flung as Italy, Cameroon and Taiwan projected onto the installation. Notions of 'inside' and 'outside' are overturned, prompting us to consider the connections between disparate peoples rather than fixating on their differences.
SS

Rosemarie Trockel

Table 7
2008

Since the mid-1980s, Rosemarie Trockel has undermined assumptions about art production, value and gender in her open adoption of the language, material and processes typically associated with feminine domestic pursuits or craft. She first became known for her machine-knitted wool panels incorporating ubiquitous symbols such as the hammer and sickle or Playboy bunny ordered in repetitive patterns, their tactility contradicting their apparently critical stance. A series of works known as 'stoves' adapted the language of Minimalist sculpture: freestanding steel boxes were painted white and topped with hotplates, in a conflation of artwork and housework.

Landscapian shroud of my mother (2008) was part of an exhibition in the same year entitled *Favorite Things*, which featured a group of sculptures whose explicit titles and re-workings of domestic furnishings evoked a very personal narrative. Various sofa-like objects in the exhibition referred to Trockel's partly home-based working practice, where she had used the sofa as a kind of easel to prop up her drawings. In *Landscapian shroud of my mother*, several raised rectangles of white-glazed ceramic on a large white steel platform surround a sepulchral central recess, draped with a black cloth. The sculpture is like a haunting Minimalist memorial, suggesting death and memory, but also traces left by the body on the furniture it once occupied.

Trockel's recent series of table sculptures combines generic clean-lined Modernist furnishings with human appendages, in a juxtaposition not only of form and function, but also the contrasting facture of lumpy, handmade ceramic structures and sharply produced design. The first versions have well-shaped kneeling limbs in place of the table legs, but as the series progresses, these become increasingly rough and violently truncated, suggesting an implicit subservience in man's dependence on the products of his highly developed civilisation. In *Table 7* (2008), the thick human limbs are cut off just below the knee, in contrast to the slim straight table legs: man and furnishing may fuse into one, but it is not a harmonious fusion.

KB

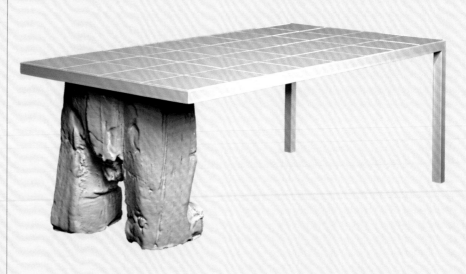

Tatiana Trouvé

Tatiana Trouvé's sculptures resemble pieces of furniture or equipment but are always eerily suspended between functionality and unusability. To create her spatial interventions, Trouvé appropriates industrial, utilitarian materials such as copper wiring, Plexiglas and cement, and combines them with suggestive elements like leather, mirrors, metal bars, thick ropes and large boulders. She configures them in coolly minimal constellations to create an atmosphere of anticipation and suspension — halfway between an imaginary Wonderland-esque rabbit hole and a nightmarishly warped hospital room. Even the sparest interventions evoke a potential threat or impending harm. Some invite us to enter; others refuse entry, like the mirrored hallway we can only gaze into through a locked glass door. Often, Trouvé places a confounding accent in these stark interiors, like a pool of yellow goo or a pair of patent-leather shoes.

The configuration of wooden and Formica objects in *Untitled* (2007) suggests a domestic setting — possibly a prefab kitchen — with slightly skewed dimensions. Its pristine white surfaces indicate that it is waiting to be installed, but its exposed wires hint that it has just been ripped out. Four knobs vaguely replicate the controls for a hob and a black Formica square the promise of an oven door. A pyramid traced by stiffened electrical cords nearby looks as if it is held upright by an invisible energy coursing through its wires. But another object, a curved white wooden trolley that seems designed to hold a horse's saddle, over which are draped black leather straps adorned with bells, suggests something perverse or sinister — a specially-designed holding bay for tools of torture? The tense configuration of objects that defines this instrumentalised room — anything from a sex chamber to a dentist's office — dissolves when we fail to pinpoint the objects' exact functions.
CL

Nicole Wermers

Nicole Wermer's sculptures and collages borrow their look and feel from department stores, shop window display and advertising, bringing abstraction up close with the furnishings of consumerism. A series of half-size columns with various decorative surfaces made from Plexiglas, painted wood, metal, glass and plastic appear to be ruminations on models of late Minimalism, but turn out to be prototypes for ashtrays, their tops filled with sand and cigarette butts (*French Junkies #5*) (2002). With their cheap materiality and degraded purpose, these hybrid objects straddle the boundary between art and functional design. In *Untitled bench* (2009), a line of rocks on the floor, each a different colour, shape and form, is encased in a Plexiglas box to form a bench, juxtaposing the rawness of the boulder, which was after all man's original seat, with the industrially produced Plexiglas.

Such vacillations flow throughout Wermers' practice, leaving it stranded in an ambiguous field of meaning. Works such as *Untitled (steel)* (2004), where two upright steel rhomboid structures face each other on the floor, seem to approach science fiction, suggesting a spatial interruption or portal, which imbues the area between the forms with an unknown force. But they are also strangely reminiscent of the security sensors installed near shop doorways to detect shoplifters. The freestanding threshold implies a spatial and social transition, establishing a link between the viewer and the space, but provides no instructions. Similar conflations of reference occur in *Untitled Forcefield (Sandportal)* (2008), a large Perspex structure like a vertical rectangle. The hollow, transparent form is half-filled with sand, the uppermost surface of which is purple. It brings to mind kitsch pictures made of coloured sand, but also raises the themes of gravitational force and physical sensation.

KB

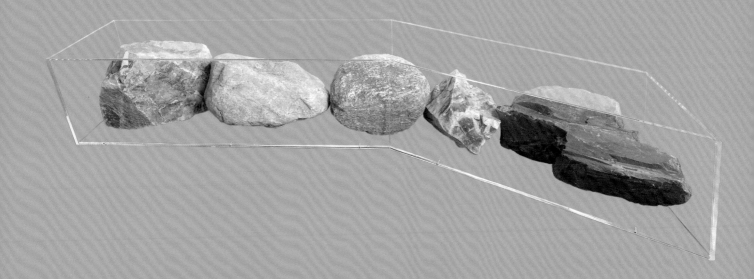

Untitled (steel)
2004

Franz West

Franz West aims to bring the real world and the realm of art closer together. Explaining that he himself 'came to art via the places where artists meet, places where you would go and sit', he wanted from the outset to expand the boundaries of sculpture and to overturn traditional expectations of art as something that is untouchable and sacrosanct. His work features sculptures that invite interaction, and furniture-based installations which transform galleries, museums and public spaces into social environments. In 1974 he began making his *Paßstücke* or *Adaptives*; small prosthetic-like sculptures that are only complete when handled or worn by the viewer, who is obliged by their unwieldiness to strike extraordinary and often ridiculous poses. Following on from these, West began to make 'sitting sculptures' for museums and galleries in order to encourage visitors to relax, talk and think. These works — chairs and divans made of steel bars covered in materials such as newspapers or raw linen — would only 'become art by being sat on'.

In the 1980s West started to produce sculptures meant only to be looked at. Many of these were made of papier mâché, a material that West likes because 'you can make it at home without too many complications'. A decade later, he began constructing monumental sculptures, painted in bright colours. Absurdly scatological, visceral, or phallic in shape, like the shocking-pink *Untitled* (2006), or pantomimic, like the flat-footed *Omega* (2008), which takes the majuscule form of the last letter in the Greek alphabet, these look like gigantic papier-mâché objects but are made from welded and patched aluminium. They are often designed to be functional, incorporating perches and places to rest.

Like the early 'sitting sculptures', both *Sinnlos* [*Senseless*] (2008) and *Untitled* (2010) are made from the steel rods used by the construction industry for reinforcing concrete. The outsize lamps with their huge, paint-splattered shades are the result of West's attempts to 'de-uglify' a light in his own home. *Sinnlos*, a calligraphic wall work on which you might hang your hat, relates to a doodle by the Viennese philosopher Ludwig Wittgenstein, who used it both as an example of the philosophical concept of senselessness and as a symbol of death.
HL

**Sinnlos
2008**

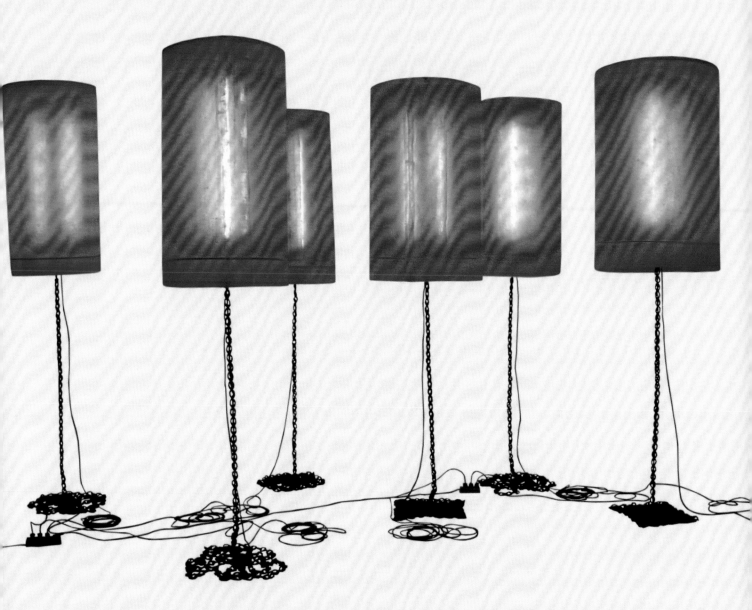

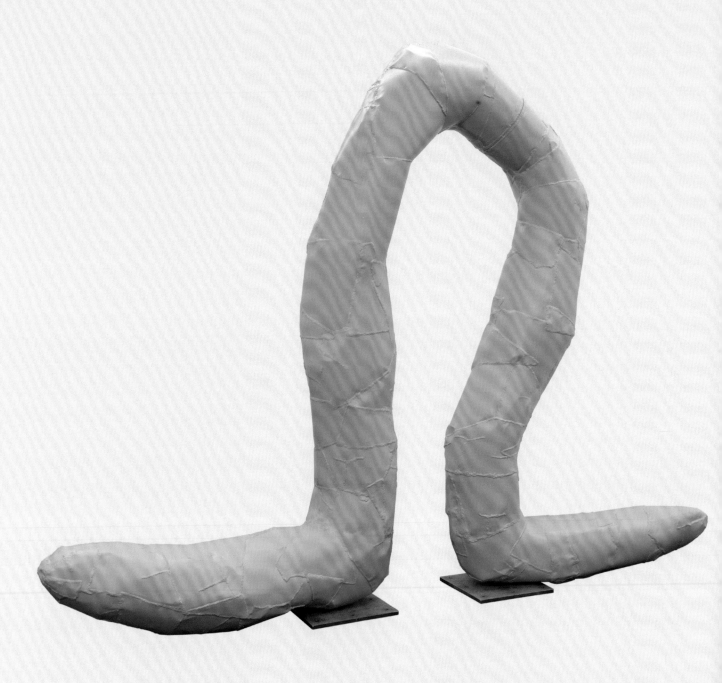

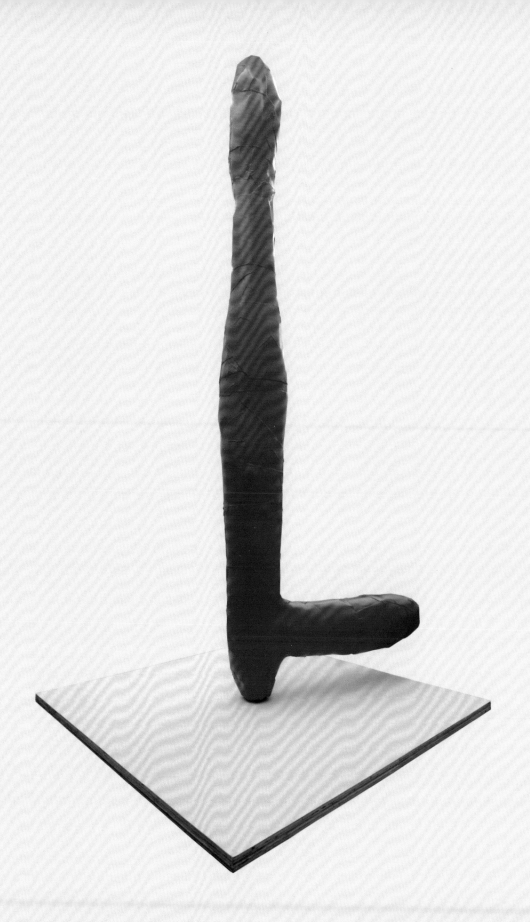

Untitled
2006

Haegue Yang

Just as the quality of light or a particular smell in a place can bring back a flood of vivid memories, Haegue Yang's installations evoke visceral experiences by drawing on historical narratives and conjuring significant but lost locations.

For her 2008 exhibition *Siblings and Twins* at Portikus in Frankfurt, Yang paired two installations based on tales of political resistance. *Red Broken Mountainous Labyrinth* (2008) told the story of the Korean freedom fighter Kim San and his biographer, the American journalist Nym Wales. In *5, Rue Saint-Benoît* (2008), Yang created an abstract version of the Left Bank home of the French filmmaker and writer Marguerite Duras, who lived at this address from 1942 until her death in 1996. Not only did Duras write many of her most famous novels and screenplays there, but the apartment also bore witness to her shifting political involvements. In the early 1940s, Duras and her husband Robert Antelme made it the hub of clandestine meetings for the French Resistance movement, until he was deported to a concentration camp. In the 1950s, it became a meeting place for debates and discussions about Communism, where Duras hosted the likes of Maurice Blanchot and Georges Bataille. This address was the site of political discussions so urgent and emotionally charged that they feel distant and unthinkable today.

Yang's geometric volumes echo those of the typical utilities and furniture one would have found in the apartment — water heater, stove, kitchen table and shower. She reproduces the objects as movable, transparent steel-framed carts illuminated by bare light bulbs. This transient mood is characteristic of her work, which has also made use of atmospheric and sensory effects, with heaters, fans, humidifiers, perfume machines and vertical blinds. Both installations in *Siblings and Twins* tangentially refer to Yang's own experience growing up in Korea, and are meant, as Yang puts it, to evoke the feeling of 'warm melancholy' that she associates with that past.
CL

Heimo Zobernig, Franz West, Zlatan Vukosavljevic

The *studiolo*, a feature of Italian Renaissance palaces, was in theory a small place of retreat, dedicated to study and contemplation, where art, music and poetry might also be privately enjoyed. In practice, such rooms were often lavishly decorated with frescoes, paintings, mirrors and furnishings, and became ostentatious displays advertising the owner's taste and culture.

This installation returns the *studiolo* to its original, modest ideal of a sequestered inner sanctum in which conceptual thought leads to a higher plane of creative and aesthetic achievement. Suspended above the gallery floor, the room consists of four white fabric walls, with two transparent silver foil mirrors. Inside it, there is a table with a Day-Glo yellow glove that inflates and deflates, symbolising the passage of time, and a chair for the visitor who uses a dimmer switch to control and change the coloured lighting that illuminates the space. Under the table there is a 'receptacle of energy' connected to an 'orgone box' beneath the room. (Orgone energy — an idea promoted by the Austrian psycho-analyst Wilhelm Reich in the 1930s — was supposedly a universal life force that could be collected in specially designed accumulators and used as a form of therapy.)

Studiolo is a collaboration between three artists, each of whom in their own practice invites the viewer's active participation, whether physical, mental or psychological. Franz West has long maintained that 'it doesn't matter what the art looks like but how it's used', and wants people 'to be able to step into it, to sit on it, lie on it'. Heimo Zobernig, who studied theatre and set design at a time when experimental theatre was seeking to break down barriers between actors and audience, makes work which contains elements of performance, design, video, sculpture, furniture and painting. Zlatan Vukosavljevic studied architecture in Belgrade. His sculptures and installations — like many of Franz West's — depend on the viewer's interaction.
HL

Artist Biographies and Selected Exhibitions

Monica Bonvicini
b. 1965, Venice, Italy
Lives and works in Berlin

Selected Solo Exhibitions
Focus Monica Bonvicini, Art Institute
of Chicago, 2009
NEVER MISSING A LINE, Sculpture
Center, Long Island, New York,
2007
*Monica Bonvicini: No Erection Without
Castration*, Kunstraum Innsbruck,
2006
Monica Bonvicini: Anxiety Attack,
Modern Art Oxford, 2003
Bonded Eternmale, Centre d'édition
contemporaine, Geneva, 2002

Selected Group Exhibitions
*Italics: Italian Art between Tradition
and Revolution 1968—2008*,
Museum of Contemporary
Art Chicago, 2009
53rd Venice Biennale, 2009
*If I Can't Dance, I Don't Want To Be
Part Of Your Revolution*, MuHKA
Museum of Contemporary
Art Antwerp, 2007
27th São Paulo Biennial, 2006
8th Istanbul Biennial, 2003

Selected Bibliography
Jan Verwoert, *Monica Bonvicini*,
Städtische Galerie im
Lenbachhaus und Kunstbau
München / Kunstmuseum Basel,
Museum für Gegenwartskunst /
DuMont, Cologne, 2009
Monica Bonvicini, *CUT*, Walther König,
Cologne, 2008
Suzanne Cotter, *Monica Bonvicini:
Anxiety Attack*, Modern Art
Oxford / Tramway, Glasgow, 2003
Monica Bonvicini: Eternmale,
Kunsthaus Glarus / Centre
d'édition contemporaine,
Geneva, 2002
Joshua Decter et al., *Monica Bonvicini:
Scream & Shake*, Le Magasin,
Grenoble, 2001

Martin Boyce
b. 1967, Glasgow, Scotland
Lives and works in Glasgow

Selected Solo Exhibitions
Commission for Massachusetts
Institute of Technology,
Cambridge, Massachusetts,
2010
No Reflections, Dundee
Contemporary Arts, 2009
We Burn, We Shiver, Sculpture Center,
New York (with Ugo Rondinone),
2008
Out of This Sun, Into This Shadow,
Ikon Gallery, Birmingham, 2008
*A Lost Cat and Alleyways, Back
Gardens, Pools and Parkways*,
Centre d'Art Contemporain,
Geneva, 2007

Selected Group Exhibitions
Scottish Pavilion, 53rd Venice
Biennale, 2009
The Third Mind, Palais de Tokyo,
Paris, 2007
STAY FOREVER AND EVER AND EVER,
South London Gallery, 2007
7th Lyon Biennial, 2003
*What If: Art on the Verge of
Architecture and Design*,
Moderna Museet, Stockholm,
2000

Selected Bibliography
Will Bradley and Amelie Rives,
No Reflections, Dundee
Contemporary Arts, 2009
Paul Elliman et al., *Martin Boyce*,
Frac des Pays de la Loire /
Westfälischer Kunstverein /
Ikon Gallery, Birmingham /
JRP|Ringier, Zurich, 2009
This Place is Dreaming, Contemporary
Art Gallery, Vancouver / Tramway,
Glasgow, 2003
Rob Tufnell, *Here + Now*, Dundee
Contemporary Arts, 2001
Will Bradley, *Zero Gravity*, Kunstverein
für die Rheinlands und
Westfalen, Düsseldorf, 2001

Lee Bul
b. 1964, Yongwol, South Korea
Lives and works in Seoul

Selected Solo Exhibitions
*A Fragmentary Anatomy of Every
Setting Sun*, Hara Museum ARC,
Gunma, Japan, 2010
Lee Bul, Fondation Cartier pour l'art
contemporain, Paris, 2007
Lee Bul, Museum of Contemporary
Art Sydney, 2004
Theatrum Orbis Terrarum, Japan
Foundation, Tokyo, 2003
Lee Bul: Live Forever, New Museum,
New York, 2002

Selected Group Exhibitions
Fluid Street — Alone, together,
KIASMA Museum of
Contemporary Art, Helsinki, 2008
10th Istanbul Biennial, 2007
*The Uncanny: Experiments in Cyborg
Culture*, Vancouver Art Gallery,
2002
6th Lyon Biennial, 2001
48th Venice Biennale, 1999

Selected Bibliography
Lee Bul: On Every New Shadow,
Fondation Cartier, Paris 2008
J-L Poitevin, *Lee Bul: The Monster
Show*, Le Consortium, Dijon,
2002
Clara Kim et al., *Lee Bul: Live Forever
Act One* and *Live Forever Act Two*,
San Francisco Art Institute, 2001
Pat Cadigan et al., *Lee Bul: The Divine
Shell*, BAWAG Foundation,
Vienna, 2001
R. Kuroda et al., *Lee Bul: Monster and
Cyborg*, Asian Art Museum,
Fukuoka, 2000

Angela Bulloch
b. 1966, Ontario, Canada
Lives and works in London and Berlin

Selected Solo Exhibitions
The space that time forgot, Städtische
Galerie im Lenbachhaus und
Kunstbau, Munich, 2008
Angela Bulloch, The Power Plant,
Toronto, 2006

Angela Bulloch, Modern Art Oxford, Oxford, 2005
To the Power of 4., Secession, Vienna, 2005
Angela Bulloch, Le Consortium, Dijon, 2005

Selected Group Exhibitions
Theanyspacewhatever, Guggenheim Museum, New York, 2008
Color Chart: Reinventing Color, 1950 to Today, The Museum of Modern Art, New York, 2008
New British Art, 3rd Tate Triennial, Tate Britain, London, 2006
50th Venice Biennale, 2003
6th Lyon Biennial, 2001

Selected Bibliography
Helmut Friedel (ed.), *Angela Bulloch: The Space That Time Forgot*, Walther König, Cologne, 2008
Helmut Draxler et al., *Angela Bulloch: Prime Numbers*, Walther König, Cologne, 2006
Dominic Eichler, *Angela Bulloch*, Secession, Vienna, 2005
Juliane Rebentisch, 'Angela Bulloch's Digital Reduction', *Parkett*, vol. 66, 2003
Nadia Schneider and Angela Bulloch, 'Pillow Talk in Public Space', *Parkett*, vol. 48, 1996

Tom Burr
b. 1963, New Haven, Connecticut, USA
Lives and works in New York

Selected Solo Exhibitions
Monica Bonvicini / Tom Burr, Städtische Galerie im Lenbachhaus und Kunstbau, Munich; Kunstmuseum Basel, Museum für Gegenwartskunst (with Monica Bonvicini), 2009
Addict — Love, Sculpture Center, New York, 2008
Moods, Secession, Vienna, 2007
The Screens, Institute for Visual Culture, Cambridge, 2003
Deep Purple, Whitney Museum of American Art, New York, 2002

Selected Group Exhibitions
Space as Medium, Miami Art Museum, 2009
Oh Girl, It's a Boy!, Munich Kunstverein, 2007
The Eighth Square, Museum Ludwig, Cologne, 2006
Whitney Biennial, Whitney Museum of American Art, New York, 2004
My head is on fire but my heart is full of love, Charlottenborg Museum, Copenhagen, 2002

Selected Bibliography
Sabeth Buchmann, *Tom Burr*, Städtische Galerie im Lenbachhaus und Kunstbau München / Kunstmuseum Basel, Museum für Gegenwartskunst / DuMont, Cologne, 2009
Florence Derieux et al., *Tom Burr: Extrospective*, Musée Cantonal des Beaux-Arts de Lausanne, JRP|Ringier, Zurich, 2006
George Baker, *Tom Burr: Deep Purple, The Other Side of the Wall*, Whitney Museum of American Art, New York, 2002
Tom Burr: Low Slung, Kunstverein Braunschweig, 2000
'Tom Burr: Private Property: anti-public sculpture', *Quiet Life*, Ursula Blickle Stiftung, Kraichtal, 2000

Los Carpinteros
Marco Antonio Castillo Valdés, b. 1971, Camagüey, Cuba
Dagoberto Rodríguez Sánchez, b. 1969, Caibarién, Las Villas, Cuba
Live and work in Havana

Selected Solo Exhibitions
La Montaña Rusa, Sean Kelly Gallery, New York, 2008
Piscina Casa (Home Pool), Le Grand Café, Centre d'art Contemporain, Saint-Nazaire, 2007
Inventing the World / Inventar el mundo, USF Contemporary Art Center, South Florida University, Tampa; Chicago Cultural Center, Chicago; Contemporary Arts Center, Cincinnati, 2005
Los Carpinteros' intervention at B. Opening, Baltic Centre for Contemporary Art, Newcastle, 2002
Ciudad Transportable, P.S.1 Contemporary Art Center, New York; Los Angeles County Museum of Art, 2001

Selected Group Exhibitions
The Kaleidoscopic Eye: Thyssen-Bornemisza Art Contemporary Collection, Mori Art Museum, Tokyo, 2009
Psycho Buildings, Hayward Gallery, London, 2008
9th Havana Biennial, 2006
51st Venice Biennale, 2005
25th São Paulo Biennial, 2002

Selected Bibliography
Gudrun Ankele and Daniela Zyman (eds), *Handwork — Constructing the World*, Thyssen-Bornemisza Art Contemporary, Vienna, 2010
Jorge Reynoso Pohlenz, 'Los Carpinteros: Utopian Model Makers', *Afterall*, no. 9, Spring / Summer 2004
Los Carpinteros, National Museum of Fine Arts, Havana, 2003
Rosa Lowinger, 'The Object as Protagonist: An Interview with Los Carpinteros', *Sculpture*, vol. 18 no. 10, December 1999
'Entrevista con Los Carpinteros', *La Dirección de la Mirada*, Stadthaus, Zurich, 1998

Loris Cecchini
b. 1969, Milan, Italy
Lives and works in Prato and Beijing

Selected Solo Exhibitions
Dotsandloops, Musée d'Art Moderne de Saint-Etienne Métropole, 2010
Empty walls, just doors, Palais de Tokyo, Paris, 2007
Cloudless, P.S.1 Contemporary Art Center, New York, 2006
Places for the show, Heidelberger Kunstverein, 2001

FWD→→: *Loris Cecchini*, Palazzo delle Papesse, Centro Arte Contemporanea, Siena, 1998

Selected Group Exhibitions

Living Rooms, Château de Chamarande, Centre d'art contemporain, 2010

The Freak Show, Musée d'art contemporain de Lyon, 2007

6th Shanghai Biennial, 2006

Five Billion Years, Palais de Tokyo, Paris, 2006

51st Venice Biennale, 2005

Selected Bibliography

Marco Bazzini et al., *Loris Cecchini: dotsandloops*, Centro per l'Arte Contemporanea Luigi Pecci, Prato / Musée d'Art Moderne Saint-Etienne Métropole, 2009

Lóránd Hegyi (ed.), *Fragile: Terres d'empathie*, Musée d'Art Moderne, Saint-Etienne, 2009

Loris Cecchini: Cloudless, Galleria Continua, Beijing, 2006

Sergio Risaliti, *Loris Cecchini: Monologue Patterns*, Galleria Photology, Milan, 2005

Lóránd Hegyi et al., *Domicile: privé / public*, Musée d'Art Moderne, Saint-Etienne, 2005

Marc Camille Chaimowicz

b. 1947, Paris, France
Lives and works in London and Burgundy

Selected Solo Exhibitions

Marc Camille Chaimowicz, Secession, Vienna, 2009

Enough Tiranny Recalled, 1972—2009, Artists Space, New York, 2009

"...In The Cherished Company of Others...", De Appel, Amsterdam, 2008

Marc Camille Chaimowicz: Some Ways by which to Live, Frac-Collection Aquitaine, Bordeaux, 2008

Marc Camille Chaimowicz: Zürich Suite, Migros Museum für Gegenwartskunst, Zurich, 2006

Selected Group Exhibitions

Entre deux actes: Loge de comedienne, Staatliche Kunsthalle Baden-Baden, 2009

New British Art, 3rd Tate Triennial, Tate Britain, London, 2006

63rd Valencia Biennial, 2005

St. Petrischnee, Migros Museum für Gegenwartskunst, Zurich, 2002

Live In Your Head, The Whitechapel Art Gallery, London, 2000

Selected Bibliography

Alexis Vaillant (ed.), *Marc Camille Chaimowicz, Forever What? (1972—2008)*, Sternberg Press, Berlin / Les presses du réel, Dijon / de Appel & PMMK, 2008

Tom Holert, *Marc Camille Chaimowicz: Celebration? Realife*, Afterall, London, 2007

Alison Bracker et al., *Marc Camille Chaimowicz: Celebration: Realife Revisited*, Walther König, Cologne, 2006

Annette Freudenberger (ed.) *Marc Camille Chaimowicz*, Kunstverein für die Rheinlande und Westfalen, Düsseldorf / König Books London, 2006

Heike Munder (ed.), *Marc Camille Chaimowicz: The World of Interiors*, JRP|Ringier, Zurich, 2006

Thea Djordjadze

b. 1971, Tbilisi, Georgia
Lives and works in Cologne

Selected Solo Exhibitions

Capital Letter, Foksal Gallery Foundation, Warsaw, 2010

Endless Enclosure, Kunsthalle Basel, 2009

Thea Djordjadze, Kunstverein Nürnberg, 2008

Possibility, Nansen, Studio Voltaire, London, 2007

Thea Djordjadze, Bonner Kunstverein, Bonn, 2001

Selected Group Exhibitions

5th Berlin Biennial, 2008

Martian Museum of Terrestrial Art, Barbican Art Gallery, London, 2008

9th Lyon Biennial, 2008

Play, Stadtmuseum Düsseldorf, 2005

50th Venice Biennale, 2003

Selected Bibliography

Sarah Lowndes, 'Tokens of Sense: The work of Thea Djordjadze', *Afterall*, no. 23, Spring 2010

Anne Ellegood (ed.), *Vitamin 3-D: New Perspectives in Sculpture and Installation*, Phaidon Press, London, 2009

Thea Djordjadze: Endless Enclosure, Kunsthalle Basel, 2009

Quinn Latimer, 'Thea Djordjadze — Delicacy, vitrines and Modernism: scaffolding, relics and arcades', *frieze*, no. 125, September 2009

Thea Djordjadze, Kunstverein Nürnburg, 2008

Jimmie Durham

b. 1940, USA
Lives and works in Rome

Selected Solo Exhibitions

Rocks Encouraged, Portikus, Frankfurt, 2010

Pierres rejetées, Musée d'Art Moderne de la Ville de Paris, Paris, 2009

Jimmie Durham, Museo d'Arte Contemporanea Donna Regina, Naples, 2008

Building a Nation, Matt's Gallery, London, 2006

Jimmie Durham: Knew Urk, Walter Phillips Gallery, The Banff Centre, Alberta, 2005

Selected Group Exhibitions

10th Lyon Biennial, 2009

Martian Museum of Terrestrial Art, Barbican Art Gallery, London, 2008

Whitney Biennial, Whitney Museum of American Art, New York, 2006

51st Venice Biennale, 2005

Documenta IX, Kassel, 1992

Selected Bibliography

Jimmie Durham: Pierres rejetées (Rejected Stones), Musée d'Art Moderne de la Ville de Paris, 2009

Stefano Boeri et al., *Jimmie Durham*, Charta / Fondazione Antonio Ratti, Milan, 2005
Jimmie Durham: Semi-Specific Objects and Almost-Related Words, Leopold Hoesch Museum, Düren, 2003
Jimmie Durham, *Between the Furniture and the Building (Between a Rock and a Hard Place)*, Kunstverein Munich / Walther König, Cologne, 1998
Laura Mulvey, Dirk Snauwaert, Mark Alice Durant, *Jimmie Durham*, Phaidon Press, London, 1995

Elmgreen & Dragset
Michael Elmgreen, b. 1961, Copenhagen, Denmark
Ingar Dragset, b. 1969, Trondheim, Norway
Live and work in London and Berlin

Selected Solo Exhibitions
Home is the Place You Left, Trondheim Kunstmuseum, 2008
The Welfare Show, Serpentine Gallery, London; The Power Plant, Toronto, 2006
Spaced Out / Powerless Structures, Fig. 211, Portikus, Frankfurt, 2003
Powerless Structures, Fig. 229, CGAC, Santiago de Compostela Museum, Sala Montcada; Fundaciò La Caixa, Barcelona, 2002
Taking Place, Kunsthalle Zurich, 2001
Selected Group Exhibitions
53rd Venice Biennale, 2009
Reality Check, Statens Museum for Kunst, Copenhagen, 2008
Mapping the Self, Museum of Contemporary Art, Chicago, 2007
Skulptur Projekte Münster, 2007
25th São Paulo Biennial, 2002
Selected Bibliography
Randi Lium, *Elmgreen & Dragset: Home is the Place you Left*, Walther König, Cologne, 2008
Tony Benn et al., *This is the First*

Day of My Life, Hatje Cantz, Ostfildern, 2008
Yvonne Force Villareal, Doreen Remen, *Michael Elmgreen & Ingar Dragset: Prada Marfa*, Walther König, Cologne, 2007
Daniel Birnbaum (ed.), *Michael Elmgreen & Ingar Dragset: Spaced Out*, Portikus, Frankfurt, 2003
Beatrix Ruf (ed.), *Taking Place: The Works of Michael Elmgreen and Ingar Dragset*, Hatje Cantz, Ostfildern, 2002

Spencer Finch
b. 1962, New Haven, Connecticut, USA
Lives and works in Brooklyn, New York

Selected Solo Exhibitions
As if the sea should part and show a further sea, Queensland Gallery of Modern Art, Brisbane, 2009
Gravity Always Wins: Spencer Finch, Dundee Contemporary Arts, 2008
Spencer Finch, The Common Guild, Glasgow, 2008
What Time Is It on the Sun?, Massachusetts Museum of Contemporary Art (MASS MoCA), 2007
Through a Glass, Darkly, Mala Gallery, Museum of Modern Art, Ljubljana, 2005
Selected Group Exhibitions
53rd Venice Biennale, 2009
Turin Triennale, 2008
Equivalence: Acts of Translation in Contemporary Art, Museum of Fine Art, Houston, Texas, 2008
Nothing, Schirn Kunsthalle, Frankfurt, 2006
Whitney Biennial, Whitney Museum of American Art, New York, 2004
Selected Bibliography
Stephanie Cash, 'The Finch Effect', *Art in America*, January 2008
Spencer Finch: What Time is it on the Sun?, Massachusetts

Museum of Contemporary Art (MASS MoCA), 2007
Mark Godfrey, 'A Rainbow in Brooklyn / On Spencer Finch', *Parkett*, vol. 79, 2007
Charles LaBelle, 'Eclipse: Spencer Finch', *frieze*, no. 75, May 2003
Anton Saul, 'Color Commentary: The Art of Spencer Finch', *Artforum*, vol. 39, no. 8, April 2001

Urs Fischer
b. 1973, Zurich, Switzerland
Lives and works in Berlin, Los Angeles and Zurich

Selected Solo Exhibitions
Urs Fischer: Marguerite de Ponty, New Museum, New York, 2009
Urs Fischer, Cockatoo Island, Kaldor Art Projects and the Sydney Federation Trust, Sydney, 2007
Paris 1919, Museum Boijmans van Beuningen, Rotterdam, 2006
Urs Fischer, Camden Arts Centre, London, 2005
Urs Fischer: Kir Royal, Kunsthaus Zurich, 2004
Selected Group Exhibitions
Open Plan Living, Tel Aviv Museum of Art, 2008
The Third Mind curated by Ugo Rondinone, Palais de Tokyo, Paris, 2007
52nd Venice Biennale, 2007
Whitney Biennial, Whitney Museum of American Art, New York, 2006
50th Venice Biennale, 2003
Selected Bibliography
Massimiliano Gioni et al., *Urs Fischer: Shovel in a Hole*, JRP|Ringier, Zurich, 2009
Urs Fischer: Paris 1919, JRP|Ringier, Zurich, 2007
Garrick Jones and Beatrix Ruf, *Urs Fischer: Good Smell Make-Up Tree*, JRP|Ringier, Zurich, 2005
Mirjam Varadinis (ed.), *Urs Fischer: Kir Royal*, JRP|Ringier, Zurich, 2004

Gelitin

Wolfgang Gantner, b. 1968, Mistelbach, Austria
Ali Janka, b. 1970, Salzburg, Austria
Florian Reither, b. 1970, St. Pölten, Austria
Tobias Urban, b. 1971, Munich, Germany
Formed in 1978
Live and work in Vienna

Selected Solo Exhibitions

La Louvre, Musée d'Art Moderne de la Ville de Paris, 2008
The Dig Cunt, Coney Island, New York, 2007
Chinese Synthese Leberkäse, Kunsthaus Bregenz, 2006
Nasser Klumpatsch, Institute of Contemporary Art, Sofia, 2004

Selected Group Exhibitions

Psycho Buildings, Hayward Gallery, London, 2008
The Hamsterwheel, 52nd Venice Biennale; Le Printemps de Septembre, Toulouse; Centre d'Art Santa Mònica, Barcelona; Malmö Konsthall, 2007—8
1st Moscow Biennale of Contemporary Art, 2005
4th Shanghai Biennial, 2002
Liverpool Biennial, 2002

Selected Bibliography

Gelatin's ACB, Walther König, Cologne, 2008
Herbert Lachmayer, 'Inspiring Decadence', *Parkett*, vol. 79, 2007
Cerith Wyn Evans and Claire Bishop, *Gelitin's Sweatwat*, Gagosian Gallery, London, 2005
Maria Vassileva et al., *Please come and watch gelatin's journey to beautiful Sofia....*, Institute of Contemporary Art, Sofia / Revolver, Archiv für aktuelle Kunst, Frankfurt, 2005
Norman Dubrow, *gelatin is getting it all wrong again*, Walther König, Cologne 2003

Fabrice Gygi

b. 1965, Geneva, Switzerland
Lives and works in Geneva

Selected Solo Exhibitions

San Stae Chapel, 53rd Venice Biennale, 2009
Cubes, Musée d'Art Contemporain de Marseilles, 2007
Fabrice Gygi, Magasin 3 Stockholm Konsthall, 2006
Fabrice Gygi, Kunsthalle St Gallen, 2005
Fabrice Gygi: The Aesthetics of Control, Orange County Museum, California, 2005

Selected Group Exhibitions

Regift, Swiss Institute, New York, 2009
Une Question de Génération, Musée d'art contemporain de Lyon, 2008
25th Ljubljana Biennial, 2003
25th São Paulo Biennial, 2002
6th Cairo Biennial, 1996

Selected Bibliography

Andreas Münch (ed.), *Fabrice Gygi: A Manual*, JRP|Ringier, Zurich, 2009
Stéphanie Guex (ed.), *Gygi & Gas: Thirty-One Years of Exchange*, JRP|Ringier, Zurich, 2008
Andreas Baur, Konrad Bitterli, Lionel Bovier (eds), *Fabrice Gygi*, JRP|Ringier, Zurich, 2005
Claudia Spinelli, 'Reports from the Battle Zone', *Parkett*, vol. 63, 2001
Mai-Thu Perret 'Fabrice Gygi', *frieze*, no. 55, Nov—Dec 2000

Heiri Häfliger

b. 1969, Langnau, Switzerland
Lives and works in Vienna

Selected Solo Exhibitions

THE LAST CORNER (Not only Paper-work), Galerie Grazy, Graz, 2009
Häfliger's Objekte, Auto, Vienna, 2003
Bewilligte Ausstellung, Langnau, 2000

Selected Group Exhibitions

Brighten the Corners, Area 53, Vienna, 2010
Sternchen 15, Werkstadt Graz, 2009
Natura Morte, Schmiede Erschbaum, Außervillgraten, 2009
Tutti Frutti, Base Progetti per l'Arte, Florence, 2008
Hamsterwheel, Le Printemps de Septembre, Toulouse, 2007

Selected Bibliography

Heiri Häfliger, *paradis*, Schlebrügge, Vienna, 2007
Soufflé, eine Massenausstellung, Kunstraum Innsbruck, 2007
Broken Surface, Sabine Knust Matthias Kunz Editions, Munich, 2006

Mona Hatoum

b. 1952, Beirut, Lebanon
Lives and works in London

Selected Solo Exhibitions

Witness, Beirut Art Center, 2010
Interior Landscape, Fondazione Querini Stampalia, Venice, 2009
Present Tense, Parasol Unit Foundation of Contemporary Art, London, 2008
Artist's Choice: Mona Hatoum, Here is Elsewhere, MoMA, Queens, New York, 2003
The Entire World as a Foreign Land, Tate Britain, London, 2000

Selected Group Exhibitions

Créateurs Contemporains de Palestine, Institut du Monde Arabe, Paris, 2009
Political/Minimal, KW Institute for Contemporary Art, Berlin, 2008
Close-Up, Fruitmarket Gallery, Edinburgh, 2008
24th São Paulo Biennial, 1998
7th Cairo Biennial, 1998

Selected Bibliography

Mona Hatoum: Interior Landscape, Fondazione Querini Stampalia Onlus, Venice, 2009
Mona Hatoum, The Khalid Shoman Foundation Darat Al Funin, 2008
Mona Hatoum, Hamburger Kunsthalle, Hamburg / Hatje Cantz, Ostfildern, 2004

Michael Archer, Guy Brett, Catherine de Zegher, *Mona Hatoum*, Phaidon Press, London, 1997
Mona Hatoum, Musée national d'art moderne, Centre Georges Pompidou, Paris, 1994

Diango Hernández
b. 1970, Sancti Spíritus, Cuba
Lives and works in Düsseldorf

Selected Solo Exhibitions
The Importance of a Line, Porta 33, Funchal, Madeira, 2010
Losing You Tonight, Museum für Gegenwartskunst, Siegen, 2009
Victoria, National Museum, Warsaw, 2007
Revolution, Kunsthalle Basel, 2006
The Museum of Capitalism, Altes Museum Mönchengladbach, Germany, 2005

Selected Group Exhibitions
10th Liverpool Biennial, 2010
2nd Seville Biennial, 2006
27th São Paulo Biennial, 2006
15th Sydney Biennial, 2006
51st Venice Biennale, 2005

Selected Bibliography
Eva Schmidt (ed.), *Losing You Tonight*, Sternberg Press, Berlin, 2009
Diamonds and Stones: My Education, Damiani Editore, Bologna, 2009
Swans Without a Lake, Neuer Aachener Kunstverein, Aachen, 2007
Eleven Mistakes, Federico Luger Gallery, Venice, 2006
Anke Kempkes, *revantgarde*, Paolo Maria Deanesi Gallery, New York / Sternberg Press, Berlin 2005

Yuichi Higashionna
b. 1951, Tokyo, Japan
Lives and works in Tokyo

Selected Solo Exhibitions
Yuichi Higashionna: Venezia / Tokyo, Berengo Akatsu Collection, Tokyo, 2010

METAMORPHOSIS — Objects today Vol.4 Yuichi HIGASHIONNA, Musashino Art University, gallery αM, Tokyo, 2009
refract!, Calm & Punk Gallery, Tokyo, 2008
Yuichi Higashionna: Flowers, Day-Night, Artis Causa, Thessaloniki, 2007
Walking the Window, Ise Cultural Foundation Gallery, New York, 2002

Selected Group Exhibitions
Use & Mention, Stephen Lawrence Gallery, University of Greenwich, London, 2010
Second Nature, Rundetaarn, Copenhagen, 2009
Roppongi Crossing 2007: Future Beats in Japanese Contemporary Art, Mori Art Museum, Tokyo, 2007
Sea Art Festival, 5th Busan Biennial, 2006
Officina Asia, Galleria d'arte Moderna, Bologna, 2004

Selected Bibliography
Yuichi Higashionna: Flowers, True Ring Ltd, Tokyo, 2009
Karen Rosenburg, 'Art in Review: Yuichi Higashionna', *The New York Times*, 30 October 2008
Yuichi Higashionna, Gasbook 25, Tokyo, 2008
Untitled Works of Yuichi Higashionna, Postcard Gallery, Amus, Osaka, 2001
Hina-gata, Nadiff, Tokyo, 2000

Jim Lambie
b. 1964, Glasgow, Scotland
Lives and works in New York and Glasgow

Selected Solo Exhibitions
Unknown Pleasures, Hara Museum of Contemporary Art, Tokyo, 2008
RSVP: Jim Lambie, Museum of Fine Arts, Boston, 2008
Eight Miles High, Australian Centre for Contemporary Art, Melbourne, 2008

Directions — Jim Lambie, Hirshhorn Museum, Washington DC, 2006
Male Stripper, Museum of Modern Art, Oxford, 2003

Selected Group Exhibitions
Colour Chart: Reinventing Colour, 1950 to today, The Museum of Modern Art, New York, Tate Liverpool, 2008—2009
Unmonumental: The Object in the 21st Century, New Museum, New York, 2007
Turner Prize, Tate Britain, London, 2005
54th Carnegie International, Carnegie Museum of Art, Pittsburgh, 2004
Scottish Pavilion, 50th Venice Biennale, 2003

Selected Bibliography
Briony Fer et al., *Colour Chart*, Tate Publishing, London, 2009
Jim Lambie: Unknown Pleasures, Hara Museum of Contemporary Art, Tokyo, 2008
Rob Tufnell, Will Bradley, *Voidoid*, Walther König, Cologne, 2004
Michael Bracewell et al., *Jim Lambie: Male Stripper*, Modern Art Oxford, 2004
Will Bradley, *Painting Not Painting*, Tate Publishing, London, 2003

Sarah Lucas
b. 1962, London, UK
Lives and works in Sussex and London

Selected Solo Exhibitions
Nuds, Museum of Cyladic Art, Athens, 2010
Sarah Lucas, Frans Hals Museum, Haarlem, 2006
Sarah Lucas, Kunsthalle Zurich; Kunstverein Hamburg; Tate Liverpool, 2005
Sarah Lucas: Beyond the Pleasure Principle, The Freud Museum, London, 2000
Sarah Lucas, Museum Boijmans van Beuningen, Rotterdam, 1996

Selected Group Exhibitions

Pop Life: Art in a Material World, Tate Modern, London; Hamburger Kunsthalle, 2009—2010

Cult of the Artist: 'I can't just slice off an ear every day', Hamburger Bahnhof Museum für Gegenwart, Berlin, 2008

The Third Mind curated by Ugo Rondinone, Palais de Tokyo, Paris, 2007

The Devil of Hearth and Home, La Triennale di Milano, 2006

Public Offerings, Museum of Contemporary Art, Los Angeles, 2001

Selected Bibliography

Amna Malik, *Sarah Lucas: Au Naturel*, Afterall, London, 2009

Jörg Heiser, 'Sarah Lucas: Kebabs and Corny Puns', *All of a Sudden: Things That Matter in Contemporary Art*, Sternberg Press, Berlin, 2008

Michele Robecchi and Francesco Bonami, *Sarah Lucas (supercontemporanea)*, Mondadori Electa, 2007

Yilmaz Dziewior et al., *Sarah Lucas: Exhibitions and Catalogue Raisonné 1989—2005*, Tate Publishing, London, 2005

Matthew Collings, *Sarah Lucas*, Tate Publishing, London, 2002

Ernesto Neto

b. 1964, Rio de Janeiro, Brazil
Lives and works in Rio de Janeiro

Selected Solo Exhibitions

Ernesto Neto: The Edges of the World, Hayward Gallery, London, 2010

Navedenga, Museum of Modern Art, New York, 2009

anthropodino, Park Avenue Armory, New York, 2009

Leviathan Thot, Panthéon, 35th Festival d'Automne, Paris, 2006

The Malmö Experience, Malmö Konsthall, 2006

Selected Group Exhibitions

São Paulo Biennial, 2010

Psycho Buildings, Hayward Gallery, London, 2008

Thin Skin: The Fickle Nature of Bubbles, Spheres, and Inflatable Structures, Scottsdale Museum of Contemporary Art, Arizona, 2002

49th Venice Biennale, 2001

Selected Bibliography

Ernesto Neto: The Edges of the World, Hayward Gallery, London, 2010

Éric Alliez, 'Body without image: Ernesto Neto's Anti-Leviathan', *Radical Philosophy*, no. 156, Jul / Aug 2009

Paulo Herkenhoff, 'Leviathan Thot: A Politics of the Plumb', *Parkett*, vol. 78, 2006

Gonçalves, Lisbeth Rebollo, 'Ernesto Neto: Sensation and Time', *Art Nexus*, v.2, no. 48, 2003

Ernesto Neto: o corpo, nu tempo, Centro Galego de Arte Contemporánea, Santiago de Compostela, 2001

Manfred Pernice

b. 1963, Hildesheim, Germany
Lives and works in Berlin

Selected Solo Exhibitions

Manfred Pernice, Secession, Vienna, 2010

Tutti, Salzburger Kunstverein, Salzburg, 2010

Ästhetische Komplexe, Kunstverein Augsburg, 2009

Que-Sah, Neues Museum, Nuremberg, 2008

Haldenslebern…, Museum Ludwig, Cologne, 2007

Selected Group Exhibitions

Le Festival, Centre Georges Pompidou, Paris, 2009

55th Carnegie International: Life on Mars, Carnegie Museum of Art, Pittsburgh, 2008

Unmonumental: The Object in the 21st Century, New Museum of Contemporary Art, New York, 2007

50th Venice Biennale, 2003

Documenta XI, Kassel, 2001

Selected Bibliography

Jennifer Allen et al., *Manfred Pernice: Que-Sah*, Verlag für modern Kunst, Nuremberg, 2010

Johannes Porsch et al., *Transitory Objects*, Walther König, Cologne, 2009

Axel Jablonski (ed.), *Ästhetische Komplexe: Josef Dabernig / Rita McBride / Manfred Pernice / Silke Schatz / Gerold Tagwerker*, Kunstverein Augsburg e.V, 2009

Manfred Pernice: Rückriem / Böll-Peilung Andere &, Nicolai Verlag, Berlin, 2007

Bernhard Bürgi et al., *Manfred Pernice*, Kunsthalle Zurich, 2000

Raqs Media Collective

Jeebesh Bagchi, b. 1965, New Delhi, India
Monica Narula, b. 1969, New Delhi, India
Shuddhabrata Sengupta, b. 1968, New Delhi, India
Formed in 1992
Live and work in Delhi

Selected Solo Exhibitions

The Things That Happen When Falling in Love, Baltic Centre for Contemporary Art, Gateshead, 2010

The Surface of Each Day is a Different Planet, Art Now Lightbox, Tate Britain, London, 2009

When the scales fall from your eyes, Ikon Gallery, Birmingham, 2009

The KD Vyas Correspondence, Vol. 1, Museum of Communications, Frankfurt, 2006

The Wherehouse, Palais des Beaux-Arts, Brussels, 2004

Selected Group Exhibitions

Indian Highway, Serpentine Gallery, London, 2008

15th Sydney Biennial, 2006

51st Venice Biennale, 2005

4th Liverpool Biennial, 2004
Documenta XI, Kassel, 2002

Selected Bibliography
Seepage, Raqs Media Collective, Sternberg Press, Berlin, 2010
Pamela M. Lee, 'How to be a collective in the age of consumer sovereign: Raqs Media Collective', *Artforum*, October 2009
Time Book, Raqs Media Collective, Onestar Press, Paris, 2009
The KD Vyas Correspondence: Vol. 1, Revolver, Berlin / Museum für Kommunikation, Frankfurt, 2006
The Impostor in the Waiting Room, Bose Pacia Gallery, New York, 2004

Ugo Rondinone
b. 1964, Brunnen, Switzerland
Lives and works in New York

Selected Solo Exhibitions
The Night of Lead, Aargauer Kunsthaus, Aarau, 2010
Sunrise East, Jardin des Tuileries, Paris, 2009
Art Wall Project, ICA Boston, 2009
Ugo Rondinone, Arario Seoul, South Korea, 2007
Ugo Rondinone — zero built a nest in my navel, Whitechapel Gallery, London, 2006

Selected Group Exhibitions
Reference and Affinity, Kunstmuseum Luzern, 2010
Chromamix 2, Musée d'Art Moderne et Contemporain, Strasbourg, 2009
Cult of the Artist: 'I can't just slice off an ear every day', Hamburger Bahnhof, Berlin, 2008
52nd Venice Biennale, 2007
Prague Biennale, 2005

Selected Bibliography
Allesandro Rabottini, 'Ugo Rondinone', *frieze*, no. 121, March 2009
Iwona Blazwick et al., *Ugo Rondinone: Zero built a nest in my navel*, Whitechapel Gallery, London / JRP|Ringier, Zurich, 2006

Ugo Rondinone: Our Magic Hour, Museum of Contemporary Art, Sydney, 2003
Gaby Hartel et al., *Ugo Rondinone: no how on*, Walther König, Cologne, 2002
Christina Bechtler (ed.), *Ugo Rondinone: Hell, Yes*, Hatje Cantz, Ostfildern, 2001

Doris Salcedo
b. 1958, Bogotá, Colombia
Lives and works in Bogotá

Selected Solo Exhibitions
Neither, The Inhotim, Centro de Arte Contemporânea, Belo Horizonte, 2008
Shibboleth, Turbine Hall, Tate Modern, London, 2007
Noviembre 6 y 7, Palace of Justice, Bogotá, Columbia, 2002
Doris Salcedo, Camden Arts Centre, London, 2001
Unland: Doris Salcedo, New Museum, New York, SITE Santa Fe; San Francisco Museum of Modern Art; Tate Gallery, London, 1998—9

Selected Group Exhibitions
América Latina: arte y confrontación, 1910 — 2010, Museo del Palacio de Bellas Artes, Mexico City, 2010
Portrait / Embodiment / Homage, The Pulitzer Foundation for the Arts, St Louis, Missouri, 2007
Abyss, Turin Triennale, 2005
8th Istanbul Biennial, 2003
Documenta XI, Kassel, 2002

Selected Bibliography
Of What One Cannot Speak: Doris Salcedo's Political Art, University Of Chicago Press, Chicago, 2010
Achim Borchardt-Hume, *Doris Salcedo: Shibboleth*, Tate Publishing, London, 2007
Rod Mengham, *Doris Salcedo*, White Cube, London, 2007
Nancy Princenthal et al, *Doris Salcedo*, Phaidon Press, London, 2000
Charles Merewether et al, *Unland: Doris Salcedo*, New Museum of Contemporary Art, New York, 1998

Jin Shi
b. 1976, Henan Province, China
Lives and works in Hangzhou

Selected Solo Exhibitions
Jin Shi: Unrealistic Reality, Magee Art Gallery, Madrid, 2009

Selected Group Exhibitions
Jungle: A Close-Up Focus on Chinese Contemporary Art Trends, Platform China Space, Beijing, 2010
Beijing Time, Matadero, Madrid, 2009
Big World: Chinese Contemporary Art, Chicago Culture Center, Chicago, 2009
7th Shanghai Biennial, 2008
2nd Chengdu Biennial, 2005
10th Zhejiang Art Exhibition, Hangzhou, 2004

Selected Bibliography
Jin Shi: Unrealistic Reality, Trojan Press, Spain, 2009
Thinghood: Object-related Themes in Contemporary Art, Magee Art Gallery, Beijing, 2008

Roman Signer
b. 1938, Appenzell, Switzerland
Lives and works in St Gallen

Selected Solo Exhibitions
Swiss Institute, New York, 2010
Roman Signer, Werke 1975 — 2007, Kunsthaus Zug, 2009
Roman Signer: Projektionen. Filme und Videos 1975—2008, Hamburger Kunsthalle, Hamburg, 2009
Roman Signer: Works, Fruitmarket Gallery, Edinburgh, 2007
Roman Signer: Fotografie di viaggio, Istituto Svizzero di Roma, Rome, 2007

Selected Group Exhibitions
Catch Me! Grasping Speed, Kunsthaus Graz, 2010
Die Kunst ist super!, Hamburger Bahnhof, Berlin, 2009
Ballerina in a whirlpool, Kunsthalle Baden-Baden, 2006
Eye on Europe, The Museum of Modern Art, New York, 2006
One second one year, Palais de Tokyo, Paris, 2006

Selected Bibliography
Peter Zimmermann (ed.), *Roman Signer: Catalogue Raisonné of Works 1971—2002*, 3 vols, Walther König, Cologne, 2010
Agathe Nisple et al., *Roman Signer: Weissbad — End de Wölt und andere Stationen*, Hof Weissbad AG, Weissbad, 2009
Hans Dünser (ed.), *Roman Signer. "Installation" — Unfall als Skulptur*, Verlag für Moderne Kunst, Nuremberg, 2008
Gerhard Mack et al., *Roman Signer*, Phaidon Press, London, 2006
Michaela Unterdörfer (ed.), *Roman Signer. Installation im Wasserturm*, Oktagon Verlag, Cologne, 2001

Pascale Marthine Tayou
b. 1967, Yaoundé, Cameroon
Lives and works in Ghent

Selected Solo Exhibitions
Pascale Martine Tayou, Malmö Konsthalle, 2010
Plastik Diagnostik, Milton Keynes Gallery, 2007
Pascale Marthine Tayou, Kunsthalle Wien, Vienna, 2006
Rendez-vous, Museum Marta Herford, 2005
Pascale Marthine Tayou, S.M.A.K, Ghent, 2004

Selected Group Exhibitions
53rd Venice Biennale 2009
A Certain State of the World? Works from the François Pinault Foundation, Garage Center for Contemporary Culture, Moscow, 2009
Altermodern, 4th Tate Triennial, Tate Britain, London, 2009
50 Moons of Saturn, Turin Triennale, 2008
9th Havana Biennial, 2006

Selected Bibliography
Nicolas Bourriaud and Pier Luigi Tazzi, *Pascale Marthine Tayou: Le grand sorcier de l'utopie*, Pistoia, 2009
Pascale Marthine Tayou: Matiti Elobi, Gallery Continua and Château des Blandy-le-Tour, France 2008
Federica Beltrame et al., *Zigzag Zipzak!*, Gallery Continua, Beijing, 2007
Jan Hoet et al., *Rendez-vous*, Museum Marta Herford, 2005
Jan Hoet et al., *Pascale Marthine Tayou*, S.M.A.K, Ghent, 2004

Rosemarie Trockel
b. 1952, Schwerte, Germany
Lives and works in Cologne

Selected Solo Exhibitions
Deliquescence of the Mother, Kunsthalle Zurich, 2010
Post-Menopause, Museum Ludwig, Cologne; MAXXI, Rome, 2005—6
Rosemarie Trockel: Selected Drawings, Objects and Videoworks, 2003—7
Spleen, Dia Center for the Arts, New York, 2002
Rosemarie Trockel: Werkgruppen: 1986—1998, Staatsgalerie Stuttgart; Hamburger Kunsthalle, Hamburg; Whitechapel Gallery, London, 1998—9

Selected Group Exhibitions
The Luminous West, Kunstmuseum Bonn, 2010
55th Carnegie International, Carnegie Museum of Art, Pittsburg, 2008
9th Lyon Biennial, 2007
Documenta XII, 2007
48th Venice Biennale, 1999

Selected Bibliography
Deliquescence of the Mother, Kunsthalle Zurich, 2011
Anita Haldemann, *Rosemarie Trockel: Drawings*, Hatje Cantz, Ostfildern, 2010
Gregory Williams, Silvia Eiblmayr (eds), *Rosemarie Trockel: Post-Menopause*, Museum Ludwig, Cologne / MAXXI, Rome, 2005
Lynne Cooke (ed.), *Rosemarie Trockel*, Sammlung Goetz, Munich, 2002
Rosemarie Trockel: Werkgruppen 1986—1998, Hamburger Kunsthalle, Hamburg, 1998

Tatiana Trouvé
b. 1968, Cosenza, Italy
Lives and works in Paris

Selected Solo Exhibitions
Il Grande Ritratto, Kunsthaus Graz, 2010
A stay between enclosure and space, Migros Museum, Zurich, 2009
4 between 3 and 2, Centre Georges Pompidou, Paris, 2008
Double bind, Palais de Tokyo, Paris, 2007
Aujourd'hui, hier, ou il y a longtemps, Musée d'art contemporain, Bordeaux, 2003

Selected Group Exhibitions
Spatial City: An Architecture of Idealism, Museum of Contemporary Art, Detroit; Hyde Park Art Center, Chicago; Institute of Visual Arts, Milwaukee, 2010
50 Moons of Saturn, Turin Triennale, 2008
Manifesta 7, Rovereto, 2008
52nd Venice Biennale, 2007
50th Venice Biennale, 2003

Selected Bibliography
Catherine Millet et al., *Tatiana Trouvé*, Walther König, Cologne, 2008

Jean-Pierre Bordaz et al., *Tatiana Trouvé: 4 between 3 and 2*, Éditions du Centre Pompidou, Paris, 2008
Lapsus, Mac / Val, Vitry-sur-Seine, 2007
Hans-Ulrich Obrist, *Djinns*, CNEAI, Chatou, 2005
Elie During et al., *Tatiana Trouvé: aujourd'hui, hier, ou il y a longtemps*, Musée d'art contemporain, Bordeaux, 2003

Zlatan Vukosavljevic
b. 1958, Požarevac, Serbia
Lives and works in San Diego

Selected Solo Exhibitions
Speed, Trash and Psych, Southwestern College Art Gallery, San Diego, 2010
Tent City, The New Children's Museum, San Diego, 2008
Devil's Sonata, Koje 38, Salzburg, 2006
Collapsible Monuments, Thrust Project, New York, 2006
Selected Group Exhibitions
Super Farmers' Market, Handel Street Project, London, 2010
The New Festival, Centre Georges Pompidou, Paris, 2009
Reminiscing in Tempo, Thrust Project, New York, 2006
Studiolo, Palazzo Lantieri, Gorizia; Palazzo Barbarigo, Venice (with Franz West and Heimo Zobernig), 2005
Home Scenes: 8 days of revision, MAK Center for Art and Architecture, Los Angeles, 2002
Selected Bibliography
Patricia Grzonka, *100 Artist-In-Residency Quartier 21*, Museums Quartier, Vienna, 2006
Jason Rhoades, Pavel Sfera, Zlatan Vukosavljevic, *Fema & Fortuna Cowllages*, 2006
Katie Kurtz, 'The Red Thread: Glimpse of International Art in Vienna', *The Stranger*, April 2005

Lou Anne Greenwald, *Occupied Territories*, MAK Center for Art and Architecture, Los Angeles, 2003
Tobias Ostrander, *12 scores for electronic sounds*, Flux Gallery, San Diego, 2001

Nicole Wermers
b. 1971, Emsdetten, Germany
Lives and works in London

Selected Solo Exhibitions
Anti Baby Pille, Aktualisierungsraum, Hamburg (with Alexandra Bircken), 2008
Masse und Auflösung, Aspen Art Museum, Colorado, 2007
Earring, Camden Arts Centre, London, 2006
Chemie, Secession, Vienna, 2004
Selected Group Exhibitions
Natural Wonders, Red October, Moscow, 2009
Art Sheffield 08, S1 Artspace, Sheffield, 2008
Half Square, Half Crazy, Villa Arson Centre d'Art, Nice, 2007
New British Art, 3rd Tate Triennial, Tate Britain, London, 2006
The Future Has A Silver Lining, Migros Museum, Zurich, 2004
Selected Bibliography
Kerstin Stakemeier (ed.), *Nicole Wermers: Filialen*, Produzentengalerie Hamburg, 2008
Judith Collins, *Sculpture Today*, Phaidon Press, London, 2007
Clarrie Wallis, *Tate Triennial: New British Art*, Tate Publishing, London 2006
Jan Verwoert, *Nicole Wermers, File Notes*, Camden Arts Centre, London, 2005
Tom Holert, Vanessa Joan Müller, *Chemie*, Secession, Vienna, 2004

Franz West
b. 1947, Vienna, Austria
Lives and works in Vienna

Selected Solo Exhibitions
Franz West: Auto-Theatre, Museum Ludwig, Cologne, 2009
To Build a House, You Start with the Roof, Baltimore Museum of Art, 2008
Sit on My Chair, Lay on My Bed, MAK, Vienna, 2008
Franz West, Vancouver Art Gallery, 2005
Franzwestite, Whitechapel Gallery, London, 2003
Selected Group Exhibitions
Comic Abstraction, The Museum of Modern Art, New York, 2007
52nd Venice Biennale, 2007
The Uncertainty of Objects and Ideas: Recent Sculpture, Hirshhorn Museum and Sculpture Garden, Washington DC, 2006
Blasted Allegories: Works from the Ringier Collection, Kunstmuseum Luzern, 2008
Documenta X, Kassel, 1997
Selected Bibliography
Franz West: Auto-Theatre, DuMont, Cologne, 2009
Darsie Alexander, Franz West, *To Build a House You Start with the Roof*, Baltimore Museum of Art / MIT Press, Cambridge, Massachusetts, 2008
Veit Loers, Franz West and Friedrich Christian Flick, *Franz West*, DuMont, Cologne, 2006
Franzwestite, Whitechapel Gallery, London, 2003
Robert Fleck, *Franz West*, Phaidon Press, London, 1999

Haegue Yang

b. 1971, Seoul, South Korea
Lives and works in Berlin and Seoul

Selected Solo Exhibitions

Artsonje Center, Seoul, 2010
Haegue Yang: Integrity of the Insider,
 Walker Art Center, Minneapolis,
 2009
Siblings and Twins, Portikus,
 Frankfurt, 2008
Lethal Love, Cubitt Gallery, London,
 2008
Unevenly, BAK, basis voor actuele
 kunst, Utrecht, 2006

Selected Group Exhibitions

Korean Pavilion, 53rd Venice Biennale,
 2009
55th Carnegie International,
 Carnegie Museum of Art,
 Pittsburgh, 2008
3rd Prague Biennial, 2007
27th São Paulo Biennial, 2006
4th Busan Biennial, 2004

Selected Bibliography

Doryun Chong et al., *Haegue Yang:
 Siblings and Twins*, Sternberg
 Press, Berlin / New York,
 2010
Eungie Joo, *Condensation*, 53rd
 Venice Biennale / Wiens Verlag,
 Berlin / Arts Council Korea,
 2009
Clara Kim et al., *Haegue Yang:
 Asymmetric Equality*, California
 Institute of the Arts, 2008
Binna Choi, *Community of Absence*,
 BAK, basis voor actuele kunst,
 Utrecht, 2007

Heimo Zobernig

b. 1958, Mauthen, Austria
Lives and works in Vienna

Selected Solo Exhibitions

Heimo Zobernig, CAPC, Musée
 d'art contemporain, Bordeaux,
 2009
Heimo Zobernig, MAK, Vienna, 2008
Heimo Zobernig, Tate St Ives, 2008
Heimo Zobernig, Artspace, Sydney,
 2006

Heimo Zobernig, Kunstverein
 Braunschweig, 2005

Selected Group Exhibitions

5th Enghien-les-Bains Biennial, 2004
14th Sydney Biennial, 2004
KölnSkulptur 3, Cologne, 2001
Skulptur Projekte Münster, 1997
Documenta X, Kassel, 1997

Selected Bibliography

*Heimo Zobernig and The Tate
 Collection*, Tate Publishing,
 London, 2009
Heimo Zobernig: Stellproblemen,
 Walther König, Cologne,
 2008
Heimo Zobernig, Kunstverein
 Braunschweig, Walther König,
 Cologne, 2006
Eva Badura-Triska et al., *Heimo
 Zobernig: Austelung Katerlog*,
 Walter König, Cologne, 2003
Susanne Ghez et al., *Heimo Zobernig:
 The Renaissance Society*,
 The Renaissance Society
 at the University of Chicago,
 1996

List of Exhibited Works

Dimensions are given in centimetres, height before width and depth

Monica Bonvicini
Belts Couch, 2004
Black steel, black leather belts, fabric
55 × 160 × 200
Courtesy Monica Bonvicini, VG Bild-Kunst, Bonn 2010

Chain Leather Swing, 2009
Chains (galvanised steel), chain snap closings (galvanised steel), 20 leather tassels
Dimensions variable
Courtesy Monica Bonvicini, VG Bild-Kunst, Bonn 2010

Kleine Lichtkanone, 2009
10 fluorescent lights, tie wraps, electric cables, 5 electronic ballasts with double 15W connection, circular crimp connectors, heat-shrink tubing, electrical connection
12 × 22 × 70
Courtesy Monica Bonvicini, VG Bild-Kunst, Bonn 2010

Martin Boyce
Some Broken Morning, 2008
Fluorescent light fixtures
Dimensions variable
Courtesy the artist and The Modern Institute / Toby Webster Ltd, Glasgow

Layers and Leaves, 2009
Painted steel and wood
220 × 250 × 100
Courtesy the artist and The Modern Institute / Toby Webster Ltd, Glasgow

Birch Trees and Steel, 2010
Powder-coated steel
77.5 × 73 × 61
Courtesy the artist and The Modern Institute / Toby Webster Ltd, Glasgow

Digitalis and Broken Glass, 2010
Powder-coated steel
77.5 × 73 × 61
Courtesy the artist and The Modern Institute / Toby Webster Ltd, Glasgow

Hyacinths and Pages, 2010
Powder-coated steel
77.5 × 73 × 61
Courtesy the artist and The Modern Institute / Toby Webster Ltd, Glasgow

Lee Bul
Sternbau No. 3, 2007
Crystal, glass and acrylic beads on nickel-chrome wire, stainless-steel and aluminium armature
184 × 90 × 97
Courtesy Galerie Thaddaeus Ropac, Paris / Salzburg

Angela Bulloch
Extra Time 8:5, 2006
DMX-module, birchwood, glass, RGB lighting system
75 × 50 × 50
Leeds Museums and Galleries (Leeds Art Gallery)

Smoke Spheres 2:4, 2009
19 transparent spheres, diameters 50, 30 and 16 cm, lamps, lampholders, cable, DMX controller, dimming mechanisms
Dimensions variable
Courtesy the artist, Galería Helga de Alvear, Madrid and Esther Schipper, Berlin

Tom Burr
Comfortably Numb, 2009
Wooden board, paint, pink Perspex mirror
178 × 366
Courtesy Stuart Shave / Modern Art, London

Los Carpinteros
Cama, 2007
Foam, fabric, metal, stainless steel, epoxy paint
Overall dimensions approx. 125 × 345 × 510
Coproduced by Atelier CALDER / le lieu Unique / Sean Kelly Gallery Thyssen-Bornemisza Art Contemporary

Loris Cecchini
Relativistic loop corrections to the chair function 1, 2007
Aluminium chairs, white opealine PETG, white PTFE modules, autolocking plastic ties
160 × 136 × 115
Courtesy Galleria Continua, San Gimignano / Beijing / Le Moulin

Marc Camille Chaimowicz
Dual, 2006
Finished birch ply, woven fabric, painted metal, wallpaper
Chair: 160 × 60 × 55
Chaise longue: 60 × 160 × 55
Courtesy Marc Camille Chaimowicz and Cabinet, London

Bibliothèque (green), 2009
Veneered plywood, lacquer
188 × 130 × 50
Courtesy Marc Camille Chaimowicz and Cabinet, London

Bibliothèque (pink), 2009
Veneered plywood, lacquer, decorated books
188 × 130 × 50
Courtesy Marc Camille Chaimowicz and Cabinet, London

Thea Djordjadze
Untitled, 2006
Wood, plaster
Part 1: 300 × 42
Part 2: 300 × 31
Private collection, Cologne

Deaf and dumb universe, 2008
Foam material, plaster, colour, metal
95 × 64 × 82
Collection Storch

Zurück zum Maßstab, 2009
Wood, varnish, plaster, watercolour
111 × 140 × 50
Collection Storch

Jimmie Durham
Imbissstammtisch, 1998
Wood, wheel, marble top
150 × 60
Private collection

A Meteoric Fall to Heaven, 2000
Broken chair, rock
85 × 50 × 65
Courtesy the artist and Christine König Galerie, Vienna

Close It, 2007
Metal locker, wires, audio device and sound recording
200 × 55 × 55
Courtesy the artist

Elmgreen & Dragset
Powerless Structures, Fig. 122, 2000
MDF, wood, hinges, door handles and locks, safety locks, steel chain
Each door 210 × 90
Courtesy the artists

Divided Time/Powerless Structures, Fig. 249, 2002
Aluminium, steel, paint, plastic, clock mechanism
70 × 85 × 4
Collection of Mimi Dusselier, Belgium

Powerless Structures, Fig. 133, 2002
MDF, wood, paint, hinges, door handles and locks
228.4 × 130.8
Courtesy the artists

Powerless Structures, Fig. 136, 2002
MDF, wood, paint, door handle
210 × 90
Courtesy the artists

Boy Scout, 2008
Metal bunk bed, foam rubber, sheeting, pillows, wool rugs
188 × 207 × 77
Edition of 3
Courtesy Galleri Nicolai Wallner, Copenhagen

Marriage, 2010
Metal pipe, sinks
178 × 168 × 81
Courtesy the artists and Victoria Miro, London

Time Out/Powerless Structures, Fig. 248, 2010
Aluminium, steel, paint, clock mechanism
Diameter 61
Courtesy the artists and Victoria Miro, London

Spencer Finch
Night Sky (Over the Painted Desert, Arizona, January 11, 2004), 2004
87 lamp fittings, 401 bulbs
Dimensions variable
Courtesy the artist and Lisson Gallery, London

Urs Fischer
A thing called gearbox, 2004
Cast aluminium, acrylic paint, iron rod, string, copper
231 × 68 × 67.5
Private collection, courtesy Sadie Coles HQ, London

Untitled (Door), 2006
Cast aluminium, enamel
Overall dimensions: 215 × 136 × 51
Private collection, courtesy Massimo De Carlo Gallery, Milan

Gelitin
Untitled, 2004
Mixed media
172 × 80 × 60
Collezione La Gaia, Busca, Italy

Dustbin, 2008
Plastic bin, bones
77 × 33 × 30
Courtesy the artists and Galerie Meyer Kainer, Vienna

Stromverteiler [Power Distribution], 2008
Mixed media
115 × 58 × 60
Courtesy the artists and Galerie Meyer Kainer, Vienna

Untitled, 2008
Mixed media
96 × 58 × 48
Courtesy the artists and Galerie Meyer Kainer, Vienna

Untitled, 2009
Mixed media
266 × 120 × 47
Courtesy the artists and Galerie Meyer Kainer, Vienna

Untitled, 2009
Mixed media
118 × 253 × 80
Courtesy the artists and Galerie Meyer Kainer, Vienna

today tomorrow maybee,, 2010
Several pieces of furniture, energy-saving light bulbs
150 × 450
Courtesy the artists and Galerie Meyer Kainer, Vienna

Untitled, 2010
Wood, found furniture, screws
66.5 × 91 × 85
Courtesy the artists and Galerie Meyer Kainer, Vienna

Fabrice Gygi
Table-Tente, 1993
Table, stool, fabric
74 × 174 × 112
Courtesy the artist and Galerie Chantal Crousel, Paris

Heiri Häfliger
The early bird catches the worm, 2007
Papier mâché, plastic bucket, steel, concrete, light bulb, wooden pallet
160 × 160 × 160
Courtesy the artist

Mona Hatoum
Baluchi (blue and orange), 2008
Wool
135 × 240
Courtesy the artist

Interior Landscape, 2008
Steel bed, pillow, human hair, table, cardboard tray, cut-up map, wire hanger
Installation: 270 × 400
Courtesy Alexander and Bonin, New York and White Cube, London

Static II, 2008
Steel chair, glass beads, wire
97 × 49 × 45.5
Courtesy the artist

Diango Hernández
No tea, no sofa, no me, 2009
Mixed media
300 × 120 × 200
Courtesy Galerie Michael Wiesehöfer, Galerie Barbara Thumm, Alexander and Bonin and Pepe Cobo y Cia

Leg me, chair me, love me, 2010
Mixed media
Dimensions variable
Courtesy Galerie Michael Wiesehöfer, Galerie Barbara Thumm, Alexander and Bonin and Pepe Cobo y Cia

Yuichi Higashionna
Untitled (Chandelier VII), 2005/2008
Fluorescent lights, aluminium, wire
99 × 125 × 110
Courtesy Yumiko Chiba Associates, Tokyo / Marianne Boesky Gallery, New York

Jim Lambie
Bed Head, 2002
Mattress, buttons, thread
51.4 × 191.5 × 128.9
Scottish National Gallery of Modern Art, Edinburgh

ZOBOP, 2002
Gold, silver, black and white vinyl tape
Dimensions variable
Edition of 3
Courtesy Sadie Coles HQ, London

Get Yr Freak On, 2008
Painted door, handles, mirror
260 × 90.5 × 50
Courtesy The Goss-Michael Collection

Sarah Lucas
Fuck Destiny, 2000
Red sofa bed, fluorescent lamp, box, bulbs, electrical wire, hinged wooden box
95 × 165.1 × 197.1
Cranford Collection, London

Ernesto Neto
Life is Relationship, 2007/2010
Plywood table, 8 coated MDF stools, plywood and Formica screen
Table: 62 × 130 × 150
Stools: 39 × 40 × 33
Screen: 5 panels, each 180 × 110
Courtesy the artist and Galerie Max Hetzler, Berlin

Manfred Pernice
Kaskel-treff, 2008
Mixed media
Dimensions variable
Courtesy the artist and Galerie Neu, Berlin

Usinger, 2008
Mixed media
200 × 120 × 80
Courtesy the artist and Gallery Neu, Berlin

Raqs Media Collective
A Day in the Life of___, 2009
Clock, high-gloss aluminium with LED lights
Diameter: 64.7
Courtesy the artists and Frith Street Gallery, London

Ugo Rondinone
lax low lullaby, 2010
Wood, fittings, varnish
320 × 260 × 25
Courtesy the artist, Sadie Coles HQ, London and Galerie Eva Presenhuber, Zurich

Doris Salcedo
Untitled, 2008
Wood, metal, concrete
Part 1: 76 × 268.5 × 172.5
Part 2: 78 × 247 × 121
Courtesy the artist, White Cube, London and Alexander and Bonin, New York

Jin Shi
½ Life, 2008
Mixed media
125 × 200 × 110
Courtesy the artist and Magee Art Gallery, Madrid

Roman Signer
Schwebender Tisch [Floating Table], 2005
Table, blower, sheet-iron pipe
72 × 107 × 68
Courtesy the artist and Hauser & Wirth

Pascale Marthine Tayou
Crazy-Nomad-02/Globe-trotters, 2007
Mixed media
Each approx.
170 × 130 × 130
Courtesy Galleria Continua, San Gimignano / Beijing / Le Moulin

Rosemarie Trockel
Landscapian shroud of my mother, 2008
Glazed ceramic, steel, fabric
70 × 278 × 200
Courtesy Sprüth Magers Berlin London

Table 7, 2008
Glazed ceramic, steel, wood
43 × 120 × 60.5
Courtesy Sprüth Magers Berlin London

Tatiana Trouvé
Untitled, 2007
Wood, Formica, metal, leather, bell, mirror, Plexiglas, burns
Dimensions variable
Collection FWA Lieve Van Gorp Foundation for Women Artists
Courtesy Galerie Emmanuel Perrotin, Paris

Nicole Wermers
French Junkies #5, 2002
Wood, sand, aluminium, venetian blinds, zinc
80 × 22 × 19.5
Courtesy Produzentengalerie, Hamburg and Herald St, London

Untitled (steel), 2004
Stainless steel
2 parts, each
155 × 80 × 4
Collection Silke Taprogge

Untitled Forcefield (Sandportal), 2008
Perspex, sand
212 × 114 × 22
Courtesy the artist and Produzentengalerie, Hamburg

Untitled bench, 2009
Perspex, golden quartzite, purple slate, granite, fixings
50 × 224 × 60
Courtesy Produzentengalerie, Hamburg and Herald St, London

Franz West
Untitled, 2006
Aluminium, lacquer
546 × 198 × 52
Collection Silvia Scheid and Jakob Glatz
Courtesy Galerie Meyer Kainer, Vienna

Omega, 2008
Aluminium, lacquer
307 × 391 × 70
Courtesy Peder Lund, Oslo

Sinnlos, 2008
Steel, synthetic resin varnish
2 of open edition, each 39 × 199 × 11.5
Courtesy the artist

Untitled, 2010
Metal, plastic film, electric wiring, neon light
Each approx.
270 × 90 × 90
Courtesy the artist

Haegue Yang
5, Rue Saint-Benoît, 2008
Aluminium venetian blinds, powder-coated steel frame, perforated metal plates, casters, various light bulbs, cable, yarn, vinyl fabric, metal netting, cotton, paper
Dimensions variable
Courtesy Galerie Barbara Wien Wilma Lukatsch, Berlin

Heimo Zobernig, Franz West, Zlatan Vukosavljevic
Studiolo, 2005
Trussbox, stage elements, molton, mirror foils, LDDE light system, rubber glove, wood, steel, plastic, carpet, paint, engine, electric device accumulator (orgone box), isolation material, metal, wool
236 × 336 × 280
Courtesy the artists and Galerie Chantal Crousel, Paris

Lenders

Public Collections
Scottish National Gallery of Modern
 Art, Edinburgh
Leeds Museums and Galleries
 (Leeds Art Gallery)

Private Collections and Galleries
Cabinet, London
Christine König Galerie, Vienna
Collection FWA Lieve Van Gorp
 Foundation for Women Artists
Collection of Mimi Dusselier,
 Belgium
Collection Peder Lund, Oslo
Collection Silke Taprogge
Collection Silvia Scheid and
 Jakob Glatz
Collection Storch
Collezione La Gaia, Busca, Italy
Cranford Collection, London
Frith Street Gallery, London
Galería Helga de Alvear, Madrid
Galerie Barbara Wien Wilma
 Lukatsch, Berlin
Galerie Chantal Crousel, Paris
Galerie Max Hetzler, Berlin
Galerie Meyer Kainer, Vienna
Galerie Neu, Berlin
Galerie Thaddaeus Ropac, Paris /
 Salzburg
Galleri Nicolai Wallner, Copenhagen
Galleria Continua, San Gimignano /
 Beijing / Le Moulin
Hauser & Wirth
Herald St, London
Produzentengalerie, Hamburg
Sadie Coles HQ, London
Sprüth Magers Berlin London
Stuart Shave / Modern Art, London
The Goss-Michael Collection
The Modern Institute /
 Toby Webster Ltd, Glasgow
Thyssen-Bornemisza Art
 Contemporary
Victoria Miro, London
White Cube, London
Yumiko Chiba Associates, Tokyo

Together with those lenders who
wish to remain anonymous

Related Exhibitions

Het meubel verbeeld:
Furniture as Art, 1988
Museum Boijmans Van Beuningen,
 Rotterdam
Curated by Talitha Schoon and
 Karel Schampers
Artists: John M. Armleder,
Richard Artschwager, Paul Beckman,
Scott Burton, Bazile Bustamante,
Arch Connelly, René Daniels,
Günther Förg, Jörg Immendorff,
Neil Jenney, Donald Judd, Per Kirkeby,
Imi Knoebel, Sol LeWitt, Ken Lum,
Markus Lüpertz, Kim MacConnel,
Frank Mandersloot, Reinhard Mucha,
A.R. Penck, Gerhard Richter,
Reiner Ruthenbeck, Carel Visser,
Robert Wilson

Home Show, 1988
Santa Barbara Contemporary Arts
 Forum, Santa Barbara, CA
Curated by Betty Klausner
Artists: Kate Ericson, Ann Hamilton,
Lisa Hein, David Ireland, Jim Isermann,
John Kosuth, Erika Rothenberg,
Norie Sato, Ilene Segalove,
Ursula von Rydingsvard, Mel Ziegler

Against Design, 2000
Institute of Contemporary Art,
 University of Philadelphia, PA
Curated by Steven Beyer
Artists: Kevin Appel, Angela Bulloch,
Clay Ketter, Roy McMakin,
Jorge Pardo, Tobias Rehberger,
Joe Scanlan, Joep van Lieshout,
Pae White, Andrea Zittel

What If? Art on the Verge
of Architecture and Design, 2000
Moderna Museet, Stockholm
Curated by Maria Lind, filtered by
 Liam Gillick
Artists: Lotta Antonsson,
Miriam Bäckström, Martin Boyce,
Nathan Coley, Jason Dodge,
Elmgreen & Dragset, Maria Finn,
Sylvie Fleury, Liam Gillick, Dominique
Gonzalez-Foerster, Jim Isermann,
Gunilla Klingberg, Jim Lambie,
Rita McBride, Sarah Morris,
Hajnal Németh, Olaf Nicolai,
Jorge Pardo, Philippe Parreno,
Elizabeth Peyton, Tobias Rehberger,
Gerwald Rockenschaub,
Pia Rönicke, Simon Starling,
Superflex, Apolonija Sustersic,
Rirkrit Tiravanija, Pae White,
Andrea Zittel

Designs for the Real World, 2002
Generali Foundation, Vienna
Curated by Maria Lind
Artists: Azra Aksamija, Marjetica
Potrč, Florian Pumhösl, Krzysztof
Wodiczko

Entre deux actes — Loge de
comedienne, 2009
Staatliche Kunsthalle Baden-Baden
Curated by Karola Kraus
Artists: Richard Artschwager,
Nairy Baghramian, Marc Camille
Chaimowicz, Fischli & Weiss,
Martin Kippenberger, Janette
Laverrière, Meuser, Carlo Mollino,
Claes Oldenburg, Tobias Rehberger,
Cosima von Bonin, Franz West

Interior/Exterior: Living in Art, 2009
Kunstmuseum Wolfsburg
Curated by Dr Markus Brüderlin
Artists included: Ronan & Erwan
Bouroullec, Marcel Breuer, Thomas
Demand, Caspar David Friedrich,
Zaha Hadid, Henri Matisse, Ludwig
Mies van der Rohe, Tobias Rehberger,
Henry van de Velde, Andrea Zittel

Published on the occasion of
the exhibition *The New Décor*
Hayward Gallery, London
19 June — 5 September 2010

The Garage Center for
Contemporary Culture, Moscow
October 2010 — January 2011

Exhibition curated by Ralph Rugoff
Exhibition organised by
 Richard Parry
 Assisted by Chelsea Fitzgerald

Exhibition sponsored by HSBC
as part of Festival Brazil

Sponsored by

The world's local bank

Published by Hayward Publishing
Southbank Centre
Belvedere Road
London, SE1 8XX, UK
www.southbankcentre.co.uk

Art Publisher
Mary Richards
Publishing Co-ordinator
Amy Botfield
Project Manager
Kate Bell
Production
Tim Holton
Sales Manager
Deborah Power
**Catalogue, typeface
and cover collage design**
A2/SW/HK
(*New Rail Alphabet* designed
in collaboration with
Margaret Calvert)
Printed in the UK by
Butler Tanner & Dennis

A catalogue record for this book
is available from the British Library

ISBN: 978 1 85332 285 3

This catalogue is not intended to
be used for authentication or related
purposes. The Southbank Board
Limited accepts no liability for
any errors or omissions that the
catalogue may inadvertently contain.

Distributed in North America,
Central America and South America
by D.A.P. / Distributed Art Publishers
155 Sixth Avenue
2nd Floor
New York, N.Y. 1003
Tel: +212 627 1999
Fax: +212 627 9484
www.artbook.com

Distributed outside North
and South America by
Cornerhouse Publications
70 Oxford Street
Manchester M1 5NH
Tel: +44 (0)161 200 1503
Fax: +44 (0)161 200 1504
www.cornerhouse.org/books

Cover picture credits
Collage of works by: Tom Burr
(*Comfortably Numb*, 2009),
Thea Djordjadze (*Deaf and dumb
universe*, 2008), Jimmie Durham
(*Imbissstammtisch*, 1998), Elmgreen
& Dragset (*Powerless Structures,
Fig. 133*, 2002), Gelitin (*Chandelier*,
2009, *Stromverteiler* [*Power
Distribution*], 2008 and *Untitled*,
2004), Jim Lambie (*ZOBOP*, 1999),
Los Carpinteros (*Cama*, 2007)

Endpapers
Marc Camille Chaimowicz,
Cluny, 2006

Notes on the Authors

Kirsty Bell is a Berlin-based writer, contributing regularly to publications including *frieze*, *Camera Austria* and *mousse*. She is author of numerous catalogue essays, including recent texts on Nick Mauss, Elizabeth Peyton and Caroll Dunham, and is currently researching a book about artists' houses.

Hal Foster is Townsend Martin 1917 Professor of Art and Archaeology at Princeton University, Co-editor of *October* magazine, and frequent contributor to the *London Review of Books*, *Artforum* and other journals. His *Painting and Subjectivity in the First Pop Age* will appear in 2011, to be followed by The *Art-Architecture Rapport*, a sequel to *Design and Crime (and Other Diatribes)* (2002).

Michelle Kuo is Senior Editor and forthcoming Editor in Chief of *Artforum*, and a Ph.D. candidate at Harvard University in History of Art and Architecture. She is also a contributor to publications including *Artforum*, *Bookforum*, *October*, *The Art Bulletin* and *TDR/The Drama Review*, and author of catalogue essays on the work of Robert Rauschenberg, Robert Whitman and Fluxus, among others.

Christy Lange is a Berlin-based writer and Associate Editor of *frieze*. She has written for publications including *Monocle*, *Parkett* and *TATE ETC.*, and has authored essays on artists including Thomas Demand, Douglas Gordon, Fischli & Weiss and Stephen Shore.

Skye Sherwin is a London-based writer. Formerly Deputy Editor of *ArtReview* magazine, she is a frequent contributor to the *Guardian* as well as numerous arts and culture periodicals.

Amy Botfield is Publishing Co-ordinator at Hayward Publishing, London.

Cliff Lauson (author of Ernesto Neto) is Curator at the Hayward Gallery, London.

Helen Luckett is Interpretation Manager at the Hayward Gallery, London.

Richard Parry is Assistant Curator at the Hayward Gallery, London.

Ralph Rugoff is Director of the Hayward Gallery, London.